ON SERVICE IN INDIA

THE MEIN FAMILY PHOTOGRAPHS 1870 - 1901

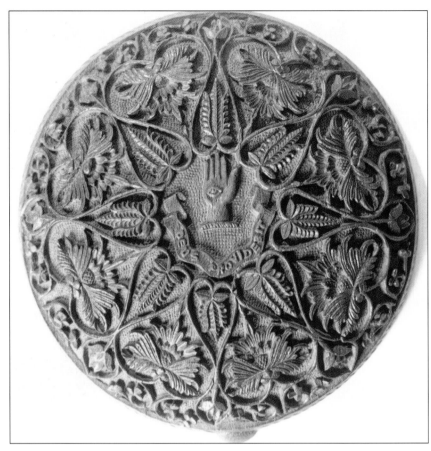

One of George Mein's letters from Kabul, 1841. To save on postage, it was customary and useful to write in both directions (across and down the page).

Carved Indian bowl with the Mein family crest.

A Note on the Text

Since this work is not meant to be either a regimental history or a study of the Afghan War, the text has been kept to a minimum consistent with explaining the photographs as they stand. There are detailed works available on the Afghan War and on the Indian Army in general to which reference may be made for further information. In the same way, the careers and campaign services of every officer portrayed in the following pages can be followed through the series of Army Lists, British and Indian, covering the period.

Inverted commas around the text accompanying the photographs indicate that the comments are by John Mein or Frederick Mein and are derived from the originals, as are most of the names shown against group photographs. Comments and areas of text not in inverted commas are supplied by the compiler.

ON SERVICE IN INDIA

THE MEIN FAMILY PHOTOGRAPHS 1870 - 1901

SELECTED AND DESCRIBED BY PETER DUCKERS

TEMPUS

Tempus Publishing Limited
The Mill, Brimscombe Port,
Stroud, Gloucestershire, GL5 2QG

ISBN 0 7524 2072 0

Typesetting and origination by
Tempus Publishing Limited
Printed in Great Britain by
Midway Clark Printing, Wiltshire

Introduction

The Meins: A Military Family

The Mein family can trace their ancestry – tentatively at least – to the early fourteenth century and to Pierre de la Main, who is said to have arrived in Scotland around 1326 to help with the reconstruction of Melrose Abbey after its destruction by the English. From him the family supposedly derives its surname and its crest: an open hand with 'the Eye of God' superimposed. Whatever the actual derivation of the family and name, they were certainly well-established around Melrose in Scotland by the early seventeenth century. During the eighteenth and nineteenth centuries many of the Meins chose to follow a military career and, by marriages into the Bowes, Desbrisay, Blundell, Hadow and Coore families, became part of an extensive network of interconnected military families. Many of these surnames were perpetuated as Christian names in the family in the nineteenth century and down to the present day.

A sizeable volume could be written on the military service, much of it spent in India, of the Meins and their related branches in the eighteenth and nineteenth centuries. But to remain with the strand of the family whose line is represented by the photographs reproduced in this work, the Meins can trace their military ancestry back to Doctor Nicol Mein (1754-1804). Said to have been a man 'bred to surgery', he entered the Madras Medical Service in 1772 as a Cadet and later Assistant Surgeon, rising to become Head Surgeon at Trichinopoly in February 1788. Nicol Mein saw active service in the Mysore campaign of 1790-2 and had the unfortunate experience of being taken prisoner when the ship he was on, the 64-gun 3rd-Rate *Yarmouth*, was captured by the French frigate *La Fine* on 15 June 1782. The experience does not seem to have done him any harm since he soon resumed his medical work. Dr Mein died in Madras on 3 April 1804.

Nicol Mein's son, John Alexander Mein (1786-1841) had a most interesting and distinguished military career. Commissioned into the 74th Highlanders, he served through the initial stages of the Mahratta War under Sir Arthur Wellesley, later to become the Duke of Wellington. J.A. Mein was wounded in the great battle of Assaye on 3 September 1803. Lord Stanhope was to record that, at the end of his life, 'the Iron Duke' came to regard Assaye as his greatest victory – outshining even Waterloo as a strictly military achievement. It is not difficult to see why he might have held this view. Wellesley's army in September 1803 only mustered something like 5,800 fighting troops while his enemy numbered up to 200,000 men, of whom perhaps 15,000 regular infantry, 20,000 irregulars and up to 60,000 cavalry would provide the main force to be met and dispersed. It was certainly no small achievement to take on this formidable army and defeat it decisively in successive attacks. As one of the few British regiments present with Wellesley's army, the 74th served with the greatest distinction throughout the battle. Posted on Wellesley's right flank, it suffered heavy casualties from the guns of the fortified village of Assaye when it was mistakenly led too close to its walls. Forming square, it then had to fight off a Mahratta cavalry charge. Later in the day, what was left of the

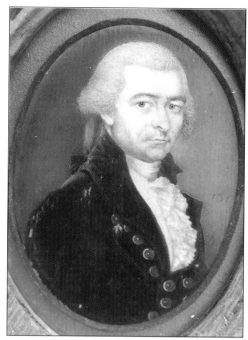

Dr Nicol Mein in 1791.

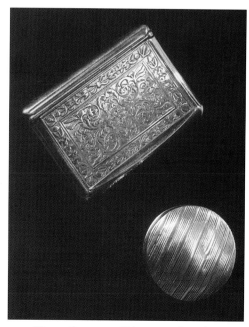

Two silver snuff-boxes taken by J.E.Mein at Vittoria.

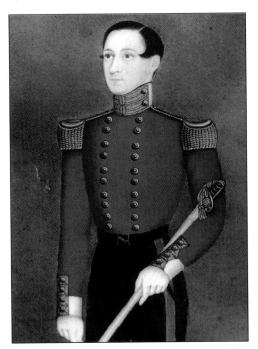

Colonel John Alexander Mein, c. 1830.

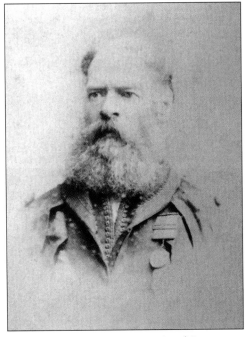

George Mein wearing his
Ghuznee Medal.

74th actually occupied Assaye village. It is said that Assaye cost more British casualties than any battle so far fought in India, with 356 killed and about 1,300 wounded. The 74th alone had 124 killed and 277 wounded – over 62 per cent of the total European casualties for the battle. Recovered from his wounds in India, John Alexander Mein served with the 74th Regiment in the Peninsular War in Spain and Southern France from 1810 onwards. At Vittoria in 1813, his regiment took part in the looting of King Joseph Bonaparte's baggage train and John Mein secured various items of Bonaparte's silverware as his own share of the plunder.

On 20 March 1823, Mein was appointed Colonel of the Regiment and rounded off his career as Governor of Trinidad, St Lucia and Antigua between 1838 and 1840. His wife, Ellen Magdalena Bowes, died at the Governor's House in Trinidad on 20 May 1840, just prior to their leaving for England. Colonel Mein himself died at Malta, where he had been sent to repair his health, in 1841. Other relatives of Colonel John Mein serving at roughly the same time were William Mein, eventually a Lieutenant Colonel in the 52nd Light Infantry and Nicol Alexander Mein who became a Lieutenant Colonel in the 43rd Light Infantry.

Of the five sons of Colonel John Alexander Mein, three (Frederick, George and John) had significant military careers. Frederick Robert Mein (1816-1880) entered the British army at the age of seventeen as an Ensign in the 1st Royal Scots. He was in Canada from 1838-41, serving with the Royals in the rebellion there, and served in Ireland, the West Indies and North America before embarking for active service in the Crimea. As a Major in the 1st Regiment, F.R. Mein was present in the battle of the Alma, the defence of Balaklava and the various siege operations against Sebastopol. As well as the British and Turkish medals for the Crimea, he was awarded the 5th Class Order of Mejidieh. He saw active service in China from 1857 to 1861, commanding the battalion during the advance on Peking and receiving the China war medal with two clasps. Robert Mein ended his career as Lieutenant Colonel of the 94th Regiment and died in England in 1880.

George Mein (1817-96) entered the 13th Light Infantry as an Ensign and served with them through the rigours of the Afghan War of 1839-42. He was present with the 13th at the siege and storming of Ghuznee in July 1839 – for which he received his only campaign medal. However, his military career was far more interesting than his single medal might imply. After serving in a number of engagements with the 13th, Lt Mein was wounded in action in the Kurd Kabul pass, where he was struck in the middle of the forehead by a bullet. Since he could not proceed with his regiment, he was sent to hospital in Kabul where it was confidently expected that he would die from the effects of what was an appalling head wound. Instead, he survived to become caught up in the epic and disastrous 'Retreat from Kabul' in January 1842. The story of that catastrophe – one of the greatest defeats a British army ever suffered – has been recounted many times. George Mein was one of the lucky few who were actually taken alive by the Afghans, in his case at Tezeen on 8 January, and he became one of the small and celebrated band of British prisoners who endured a long and fraught captivity before being released in September 1842. It is recorded that George Mein escorted Lady Sale back to the fortress of Jellalabad, where her husband, Sir Robert, had conducted a gallant defence, and that for the last few miles of the journey, George had dragged the severely wounded Lt Sturt in a blanket. Unfortunately, Sturt died of his injuries, but George Mein was personally commended in a speech in the House of Commons by the

Prime Minister, Sir Robert Peel, and was awarded a special pension for his bravery. George Mein's later career saw no further excitement on this scale; he rose steadily in rank to become a Colonel in 1870 and a Major General in 1878, but much of his later career was spent as the commander of various Depots. George Mein died at his home in St Leonard's-on-Sea in 1896. Of George Mein's sons, Frederick Coore Mein entered the army in 1868, serving in the 53rd (Shropshire) Regiment and became Lieutenant Colonel, while Alexander Lechmere Mein (1854-97) was commissioned into the Royal Engineers and served in the Afghan War of 1878-80.

The third of Colonel John Alexander Mein's sons to follow an active military career was John Desbrisay Mein (1818-1896) who broke away from the immediate example of his father and brothers serving in the British army and entered the Madras Artillery. This linked him to the service of his grandfather Dr Nicol Mein and, incidentally, to his cousin, Poulteney Mein who had also entered the Madras medical establishment. J.D. Mein was born in Carlisle in 1813 and entered the Madras Horse Artillery in December 1829, aged sixteen, after initial training at the East India Company's military college at Addiscombe. From 1830 to 1852, he served at various stations in southern India, with a brief period as Staff Officer of the Madras Artillery at Moulmein in the recently-annexed Tenasserim Provinces of Burma. It was here that he received the news of his mother's death in Trinidad, in a letter, which still survives, from his brother George in Kabul. John Desbrisay Mein first saw action in the Pegu campaign in Burma in 1852-3, as a Captain commanding a field battery in the operations which led to the capture of Prome and then at Meeaday. He later received the India General Service Medal, 1854, with clasp 'Pegu'. Much more arduous service came his way in the Central India campaign during the Indian Mutiny of 1857-58. John Mein first commanded 'A' Troop of the Madras Horse Artillery as a Captain and later Brevet Major and then commanded a brigade of artillery with the Saugor Field Force under General Whitlock. The difficulties of the operations during this rigorous campaign were compounded by the problems of climate, disease, the terrain and the distances to be covered. Mein saw action at Banda, the attack on Jhompur, the relief of the Palace of Kirwee and the storming of the Heights of Pannar and Daddree. He was twice Mentioned in Dispatches (for the battle of Banda in April 1858 and for leading a storming column against the Heights of Pannar on 29 December) and his name 'brought to the special notice of Lord Clyde'. Subsequently, he was promoted to Lieutenant Colonel 'for services in the field' and received the Indian Mutiny medal with clasp 'Central India'. The fighting in the Mutiny was the last that John Mein saw; he became Inspector of Royal Artillery, Madras Presidency, in 1867 and Colonel of 'D' Brigade, Royal Horse Artillery. J.D. Mein retired with the rank of Major General and died in December 1896, only three weeks after his brother George.

John Debrisay Mein married Susan Louisa Blundell in Secunderabad in 1848. Of the seven children of this marriage, all three surviving sons – Alexander, John and Frederick – went into the army. As a matter of interest, all three served in the Afghan War of 1878-80 at one stage or another, as did their cousin Alexander Lechmere Mein RE; there cannot have been many families with four members serving as officers in Afghanistan!

Alexander Bowes Mein (1853-1929) was commissioned into the 77th Regiment in 1871 and shortly afterwards transferred to the 22nd, becoming their Instructor of Musketry. In January

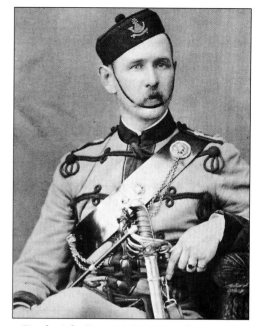

Frederick Coore Mein as Adjutant of the Oswestry Rifle Volunteers (2nd Volunteer Battalion, King's Shropshire Light Infantry), c. 1888.

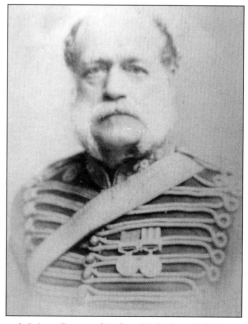

Major General John Debrisay Mein.

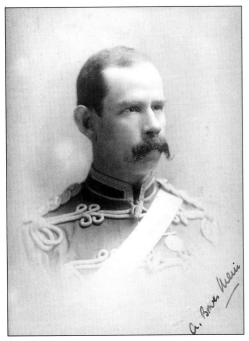

Alexander Bowes Mein.

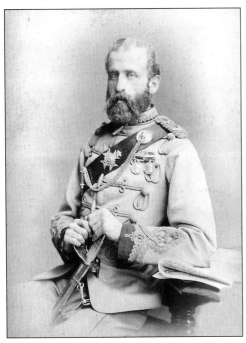

John Edward Mein.

1879, he entered the Bombay Army and joined the 21st (Marine Battalion) Bombay Infantry. He served during the Afghan War as an Assistant Superintendent with the Transport Train in the latter part of the first campaign in 1879 and received the war medal – his only campaign award. He later served at Zaila, on what was then the Abyssinian coast, supervising the movement of Egyptian troops after the Egyptian campaign of 1884-85. After a number of Staff appointments, including service as a Brigade Major in Aden 1887-89, A.B. Mein became Commandant of the 21st Bombay Infantry in 1894 and retired as a Lieutenant Colonel in 1900. He did further work during the 1914-18 War as Military Representative on the Emergency Committee at Eastbourne and died in that town in 1929.

John Edmund Mein (1851-1935) was originally commissioned into the 96th Regiment in 1870 and thereafter served in two of the finest regiments of the Punjab Frontier Force – the 5th Punjab Infantry from 1873 to 1887 and then the 6th Punjab Infantry (the Scinde Rifles). He became Commandant of the 6th Punjabis in 1892 and retired in 1901. His active service embraced the Jowaki Campaign of 1877-78, the operations around Kabul in 1879 (in which the 5th Punjabis played a prominent part), the 2nd Miranzai (Samana Ridge) campaign of 1891 and service in Waziristan in 1894-95. John Edmund Mein was an active chronicler of his own career and it is thanks to his photographic interests that we have the bulk of the photographs presented in this book. After his retirement, J.E. Mein lived at 'Pentwyn' in the village of Clyro near Hay-on-Wye but the outbreak of the First World War brought him back to service as a Censor working for the War Office in London. After the war, Colonel Mein returned to Clyro and later moved to Eastbourne. He died there on 20 February 1935, aged eighty-four. J.E. Mein had two daughters, Daphne (1889-1974) and Elfrida (1893-1989), but no sons to follow him into the army.

The youngest of the three brothers was Frederick Blundell Mein (1860-1903) who entered the army in 1878, serving in the 84th Regiment and then the 63rd. He was with the 63rd in General Phayre's army in southern Afghanistan in 1880 (for which he received the campaign medal) and in 1882 transferred into his brother John's regiment, the 5th Punjabis. While serving with the 5th, Frederick took part in the Takht-i-Suleiman surveying expedition in 1883 and was 'Mentioned' for his services. From there, he moved to the 1st Punjabis in 1897, around the time of their famous action at Maizar, though he was not present in the battle itself. He did, however, serve with the Tochi Field Force after the Maizar affair and received the India General Service Medal, 1895, with clasp 'Punjab Frontier 1897-98'. He was posted as commanding officer to the 12th 'Khelat-i-Ghilzai' Regiment, Bengal Infantry, in June 1899 but died suddenly at Frankfurt-am-Main on 29 March 1903, leaving a widow and one young son, Desbrisay Blundell Mein.

The military tradition of this branch of the family was continued by Debrisay Blundell Mein (1889-1937) who was awarded a Cadetship at Sandhurst and then entered the Indian Army, serving with the 55th (Coke's) Rifles from 1909 until his retirement in 1920. His letters covering in great detail regimental and Staff service in India 1909-14, France 1914-16, Waziristan 1917, East Africa 1917-1918, Southern Persia 1918 and the Northwest Frontier in 1919 survive and provide a marvellous insight into his career and Indian army life before and during the First World War. The letters show Debrisay Mein to have been a hard-working and meticulous officer whose gallantry in action was rewarded with the Military Cross for service in France in 1916 and

the DSO for the Third Afghan War of 1919. D.M. Mein retired as a Lieutenant Colonel in 1920, apparently dissatisfied with the promotion prospects of the post-war army and entered a civilian career, at first with the Ilford Company. However, like his father before him, he was not destined to live a long life and died in February 1937 at the age of forty-eight, as a direct result of surgery on a wartime head wound.

Taking the story of the Mein's military service even further towards our own day, Desbrisay Mein's own son, John Desbrisay Blundell Mein (b. 1935) was commissioned into the King's Royal Rifle Corps and later served as an officer in the Sierra Leone Battalion of the Royal West African Frontier Force.

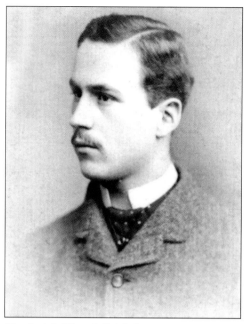

Frederick Blundell Mein as a young man.

An Introduction to the Photographs

Many of the photographs reproduced in this work are taken from six large albums, five of which belonged to John Edmund Mein and one to Frederick Blundell Mein. As the albums which belonged to J.E. Mein are more numerous and more detailed, there is naturally greater coverage of his life than that of his brother Frederick. But since both men served for a time in the same regiment – the 5th Punjab Infantry – there is an overlap in subject matter which intensifies the value of the photographs as a glimpse of a particular circle of people at one period in time. Taken together, they present a detailed record of the military careers of the brothers in India during the period 1870-1901.

The photographs naturally centre around John and Frederick Mein as they made their careers in the Indian Army – from the early days of signalling courses and language examinations, through regimental and campaign service into the higher ranks of command or Staff duties. But they also illustrate in passing many other aspects of contemporary life – the uniforms, costumes, military sites, locations and everyday events in Indian Army circles in the late nineteenth century. For the student of military dress, there are some fine studies of uniforms, headdress, medals and equipment; equally, there are displays of civilian dress as worn by off-duty officers and by their wives and families, as well as evocative views of frontier buildings and landscapes. The albums are unusually valuable in their portrayal of the native Indian officers and soldiers who shared the duties, rigours and dangers of military life on the frontier. It is uncommon to find so many named or otherwise identified depictions of native Indian soldiers in the albums of the time.

Perhaps the highpoint of the collection is the large selection of magnificent photographs taken during the Afghan War by John Burke. As historical documents, these compare with the Crimean studies of Fenton and Robertson, the Mutiny photographs of Felice Beato or the American Civil War work of Matthew Brady. John Burke (c. 1843-1900), founder partner of the firm of Baker and Burke, was a society photographer who concentrated his activities in the north-west frontier area and had studios in Peshawar and Murree; there are *carte de visite* portraits of some of the Meins taken at his workshop.

In 1879, having on earlier occasions worked under contract to the army, he was invited by the military authorities to accompany the troops of the Peshawar Valley Field Force as a

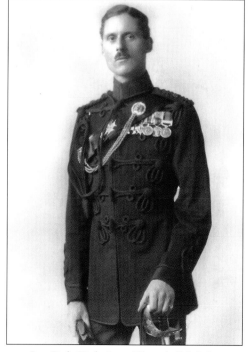

Lt-Col. Debrisay Blundell Mein
DSO, MC.

One of Burke's sale catalogues for his Afghan photographs. The ticked photographs where ones purchased by the Meins.

'photographic artist' to produce a visual record of the theatre of military operations. Burke joined the army in Afghanistan in the spring of 1879 as an official 'war artist' and, no doubt with an eye to the commercial possibilities, to take photographs of the military subjects which people in India and Britain might read about in their daily newspapers. Having worked under contract to the army before, Burke suggested his previous terms which were: 1,000 rupees per month, honorary army rank and food and transport for himself and his servants. In exchange, he would provide all necessary equipment and chemicals and supply six copies of each photograph to the military authorities, with additional copies at an agreed rate. Assuming that these terms would be accepted, Burke and his photographic wagon set off in April 1879 and began the task of recording eminent people, military groups and major sites along the Khyber route to Kabul. However, presumably to Burke's surprise, the authorities eventually rejected his terms of service and the photographer and his equipment, apparently then at Gandamak, returned to India with units of the Peshawar Valley Field Force in June 1879. Despite this rebuff, Burke was back in Afghanistan after the renewal of operations in September and completed his series of photographs of the Bala Hissar, the Residency, the city of Kabul and its environs and the Sherpur cantonments. He seems to have left Kabul in April 1880 with the British withdrawal and prepared his work for sale as single shots or in collections from his studio in Murree. Judging by albums like those of the Meins, his photographs must have found a ready market among the men who had served in Afghanistan.

Not unnaturally, Burke had had to concentrate on static scenes such as views of buildings and camps, dramatic scenery and portraits of officers, regiments and men of note. The photographic technology of his day did not permit him the luxury of 'action' shots, on the battlefield or off it, but the photographs he did take would be hard to better in their superb clarity of detail or in their historical immediacy. The studies of the Bala Hissar and the bullet-scarred Residency, Sherpur in the snow, the camps in the Khyber Pass and the views on the road to Kabul give us a glimpse of the place and the time in a way which mere words cannot match. As a window into an historical event, Burke's photographs are immeasurably valuable; they equally pass the test as superb examples of the photographer's art.

As a final note, there are in the Mein albums group photographs which are interesting on a purely human level. Since John Mein was meticulous in writing-up or naming the subjects, we have in place of the anonymous groups or portraits commonly seen in Victorian albums a succession of identifiable individuals, some of whom – along with the Mein brothers – we can see advancing through their own careers. Photographs like these do not simply record a way of life long vanished, they help to perpetuate the names and faces of men and women who spent their lives on service in India. In many cases, these must be their only remaining memorials.

ON SERVICE IN INDIA
THE MEIN FAMILY PHOTOGRAPHS 1870 - 1901

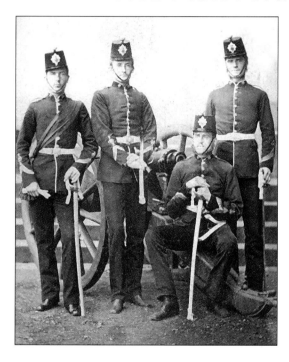

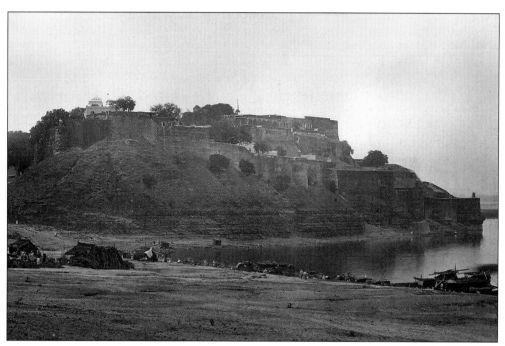

Above: J.E. Mein and fellow Cadets beginning their army career with officer training at Sandhurst, January to June 1870. Mein is seated and the other cadets are, left to right: R.F. Startin, J. Miller and H.J. Wings.

Top right: Fort Chunar, the sixteenth-century fort commanding the Ganges at Chunar , seen in 1871. J.E. Mein's first photographs in India were of this fort, which was taken by the British in 1764.

Bottom right: Officers' Quarters in Fort Chunar, 1871. J.E. Mein arrived in India in October 1870 and joined the 96th at Dum Dum. In December, he went with the Regiment to Dinapore and spent some time at Fort Chunar.

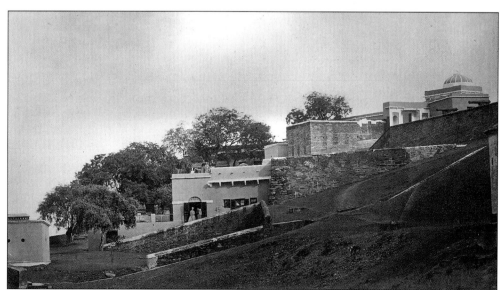

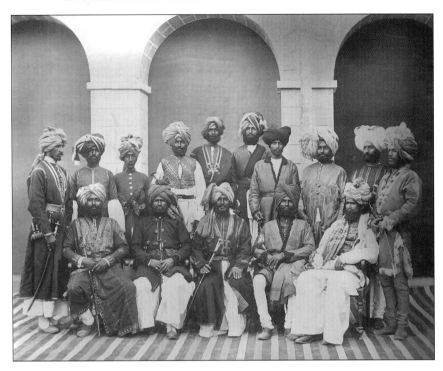

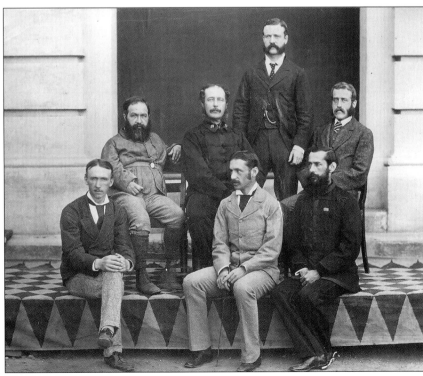

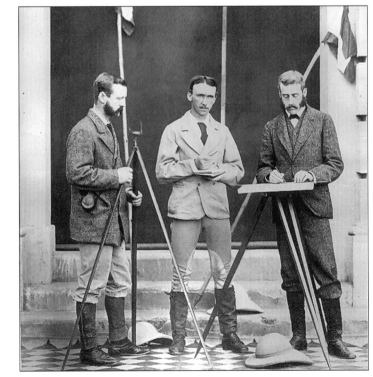

Top left: Signalling Class, Rurki, 1874. J.E.Mein on the right.

Bottom left: Native officers of the 5th Punjab Infantry, 1873. John Mein joined the 5th Punjab Infantry, a unit of the elite Punjab Frontier Force (PFF) at Dera Ghazi Khan in July 1873. The PFF (or 'Piffers') was a specialist force based in the garrisons of the North West Frontier and specially trained in the sort of rough-terrain or mountain warfare which service against the frontier tribes necessitated. This is the earliest photograph of the Regiment in the Mein albums.

Below: Officer students and staff of the Signalling Class at Rurki in 1874. J.E. Mein is seated, back right. He attended the class at Rurki from October 1874 to June 1875.

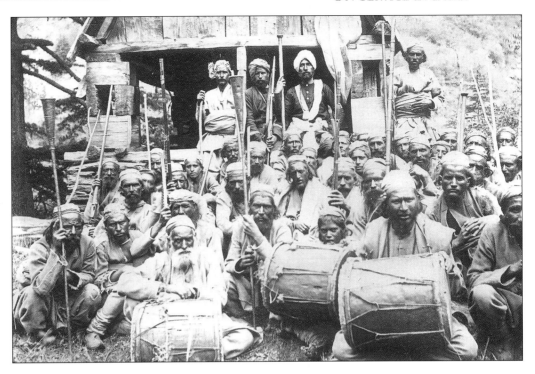

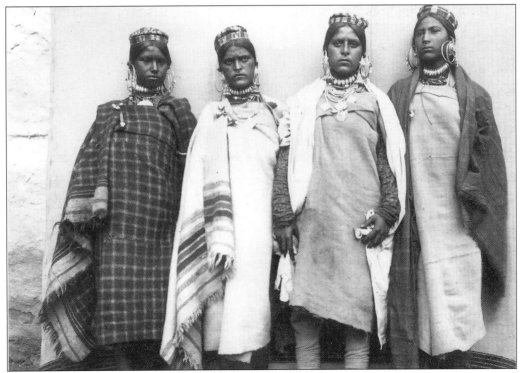

Above: 'Basdo': thought to be a personal servant or guide during the holiday at Kilar.

Top right: A Shikar (or hunting) party near Kilar. Local people were hired as beaters and bearers during a hunt. Early in his career in India (perhaps on his first leave) J.E. Mein went on a long walking and hunting tour across the Chenab and to Kilar.

Bottom right: Pangi women (women of the local villages) at Kilar, *c.* 1875.

Headmen at Kilar. The headmen or village elders were men of considerable local status who wielded great power in their communities. Their assistance and goodwill was vital to the success of any hunting or trekking expedition for such tasks as, for example, the hiring of bearers or beaters.

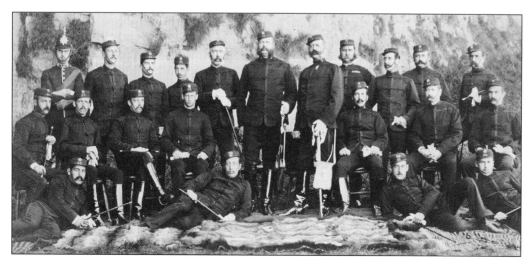

Officers of the 84th (York and Lancaster) Regiment, Dover 1878. This was the first regiment that F.B. Mein served in, joining it on 11 May 1878. British officers destined for service in the Indian army were required to do a stint of duty with a British regiment first to learn the practical day-to-day duties of an officer. Left to right, back row: Colquhoun; Lowry; Grosvenor; Scholes; Peckitt; Lees; Brownrigg; Boulger; Power; Newbigging; Briscoe. Middle row: Darnell; Rose; Kirkpatick; Nugee; Wilson; O'Grady-Haly; Ford. Front row: Lousada; Henderson; Parkin; Mein.

The 5th Punjab Infantry in the Afghan War, 1878-80

The 5th Punjab Infantry played a distinguished role in both phases of the Afghan War of 1878-80. When the war began, they were at Kohat and marched for Thal to join the Kurram Valley Field Force. They were in action on 28 November 1878, in the reconnaissance of the Peiwar Kotal position, and played a leading part in the capture of the Peiwar Kotal on 2 December. By the end of the month, they were back in the Kurram Valley and in January 1879 returned to Kohat.

When the fighting was renewed in September 1879, the 5th joined Roberts' force pushing through the Shutagardan Pass and on 6 October were prominently engaged in the battle of Charasiah. Two days later, they entered Kabul. The 5th were detached from the Kabul garrison to relieve the Shutagardan outposts and to take part in an expedition to the Maidan area and then to the Logar Valley early in December. Having been on leave in England, John Mein rejoined the 5th in Kabul on 10 December. They served throughout the operations around Kabul from 11-14 December and suffered serious casualties in the often heavy fighting around the city. The 5th then served through the siege of Sherpur, 14-23 December and on the 23 December took part in the final repulse of the Afghan forces.

Until May 1880, the 5th Punjabis remained in the Sherpur cantonment, with parties often involved in convoy escort or fatigue duties. The Regiment was in the Logar Valley in mid-May but for most of 1880 remained in Kabul, latterly in the Bala Hissar itself. The Regiment was the last to hold the fortress and heights above the city when the general withdrawal began in August.

The 5th marched from Kabul on 11 August and were back in Kohat on 10 September 1880. During the war, which comprised nearly two years of active service, they had marched 1,349 miles and lost 118 officers and men (killed or died of wounds) and had 40 men wounded.

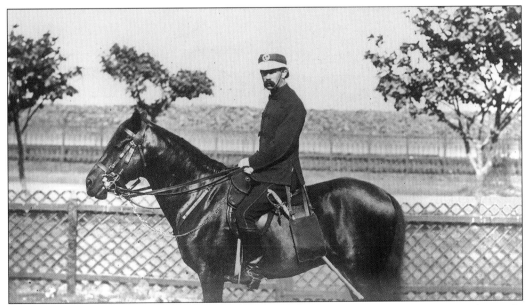

Above: Alexander Bowes Mein, Bombay Army, who was commissioned into the 77th Regiment and transferred to the 22nd becoming Instructor of Musketry. He was admitted to the Bombay Staff Corps in January 1879 and served thereafter with the 21st Bombay Infantry, eventually becoming Commandant. He served in the Afghan War, 1879-80, for which he was awarded the medal and retired as a Lieutenant Colonel.

Right: F.B. Mein's orders to embark for India, 1879.

15

The 63rd Regiment in the Afghan War, 1880-81

F.B. Mein was with the 63rd Regiment when the Afghan War began in 1878. The 63rd played no part in the first phase of the war in 1878-79. Even after the campaign resumed following the massacre of the British embassy at Kabul in September 1879, the Regiment remained in cantonments at Umballa. It was not until news was received, on 29 July 1880, of the disaster at Maiwand and the subsequent threat to Kandahar that the 63rd received orders to proceed to Quetta to join General Phayre's Kandahar Field Force. The Regiment was assembled at Quetta by the end of August 1880.

Four companies of the 63rd left Quetta on 25 and 26 August under Captain Cook and Lt H.S. Smith to join Phayre's force which was concentrating at Chaman. On arrival, they joined the 2nd Brigade of the Kandahar Field Force. The advance from Chaman began on 31 August and on 2 September, while at Mel Karez, they heard the news of Sir Frederick Roberts' signal defeat of the besieging Afghan army outside Kandahar. The four companies of the 63rd with Phayre's force proceeded to Kandahar and arrived there on 20 September.

The rest of the battalion was held at Quetta on convoy escort duties until 29 August, when they were ordered to Killa Abdullah, remaining there until 6 October, when they resumed the journey to Kandahar. Once reunited in Kandahar, the 63rd remained in cantonments there until April 1881 when the retirement from Southern Afghanistan was ordered. On 22 April, the 63rd was ordered to cover the lines of communication in the Pishin Valley, with detachments at Killa Abdullah and Gulistan Karez. Shortly afterwards, the battalion returned to Quetta and thence back to India.

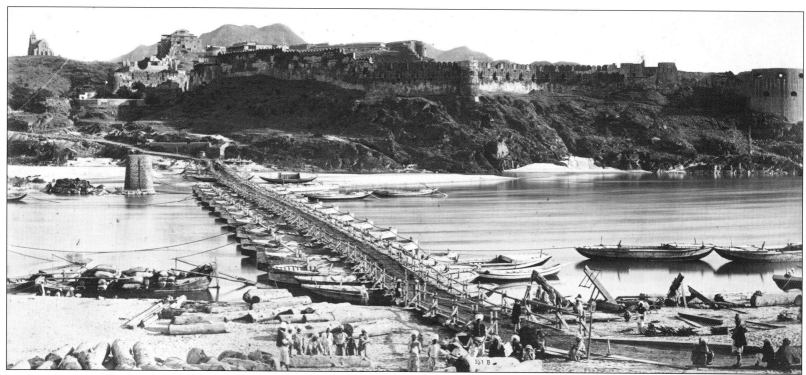

'The Bridge of Boats and Fort Attock from Khairabad'. This famous bridge across the Indus at Attock was a vital military lifeline; it had been very important in the Mutiny and was again in the Afghan War, with thousands of men and huge quantities of materiel crossing to reach Peshawar and the Khyber line to Kabul. The bridge as shown here was relatively new – its predecessor had been destroyed by floods in 1877 while the Jowaki operations were underway. The great fortress in the background was built by the Moghul Emperor Akbar in 1583.

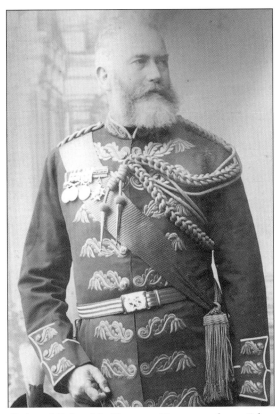

Colonel John McQueen, Commandant, 5th Punjab Infantry. One of the great figures of the Punjab Frontier Force, John W. McQueen joined the Indian Army in 1854 and rose to the rank of Lieutenant General by 1905, serving successively in the 27th Native Infantry, the 4th Punjab Infantry and the 5th Punjab Infantry. He was Commandant of the 5th Punjab Infantry from 1870. During the course of his long career, he served in the Mutiny, in operations on the Northwest Frontier in 1860 and 1869, the Jowaki Campaign of 1877-78 and in the Afghan War, 1878-80. He was appointed CB for the Afghan War and later served in the Mahsud Campaign of 1881 and the Hazara expedition of 1888, after which he was knighted. He retired in 1897, was appointed to the Grand Cross of the Bath in 1906 and died in 1909.

J.E. Mein's route to join the 5th Punjab Infantry in Kabul

J.E. Mein was not with the 5th Punjab Infantry during the first phase of the Afghan war. He was on leave in England and only reached the depot of the 5th Punjabis at Kohat in October 1879. He joined his Regiment at Kabul after travelling via the Khyber route – hence, presumably, the presence of the Burke photographs of the Khyber-Kabul line which otherwise the 5th Punjabis did not use until their return journey in August 1880. As can be seen below, his journey was inordinately fast!

'Marches from Peshawar to Cabul:

Marched with detachment from Kohat, 18th November 1879, from Peshawar 22nd November ; halt at Gundamuck three days and reached Cabul 10th December 1879.

1. *Peshawar to Jumrood – time marching – $3\frac{1}{2}$ hrs*
2. *Jumrood to Alli Musjid – $3\frac{3}{4}$ hrs, 8.3 miles*
3. *Alli Musjid to Lundi Kotal – $5\frac{1}{2}$ hrs, 10.5 miles*
4. *Lundi Kotal to Dacca – $3\frac{1}{2}$ hrs, 12.0 miles*
5. *Dacca to Basawul – $4\frac{1}{4}$ hrs, 11.1 miles*
6. *Basawul to Barikub – $3\frac{3}{4}$ hrs, 9.9 miles*
7. *Barikub to Jellalabad – $6\frac{1}{4}$ hrs, 17.7 miles*
8. *Jellalabad to Roazabad – 5 hrs, 12.8 miles*
9. *Roazabad to Fort Battye – 3 hrs*
10. *Fort Battye to Safed Sung – 4 hrs, 16.2 miles*
11. *Safed Sung to Pezwan Kotal – $4\frac{1}{4}$ hrs, 12.7 miles*
12. *Pezwan Kotal to Jugdulluck Fort – $3\frac{1}{2}$ hrs, 10.5 miles*
13. *Jugdulluk to Seh Baba – $5\frac{1}{2}$ hrs, 10.0 miles*
14. *Seh Baba to Lattaband – $4\frac{1}{2}$ hrs, 9.5 miles*
15. *Lattaband to Buthkak – 4 hrs, 9.5 miles*
16. *Buthkak to Cabul (Bala Hissar) – 4 hrs, 9.2 miles*

Total: 65.75 hours of marching, 160.09 miles

Different places marched to with the Regiment while in Afghanistan : Charasiab – Gomeran – Deh-i-Nau – Zarghun Shahr – Hissarak – Baraki-i-Rozan – Amir Killa – Tangi Wardah – Sheikabad – Killa Durani – Maidan – Lilander Pass – Tangi Saigun.'

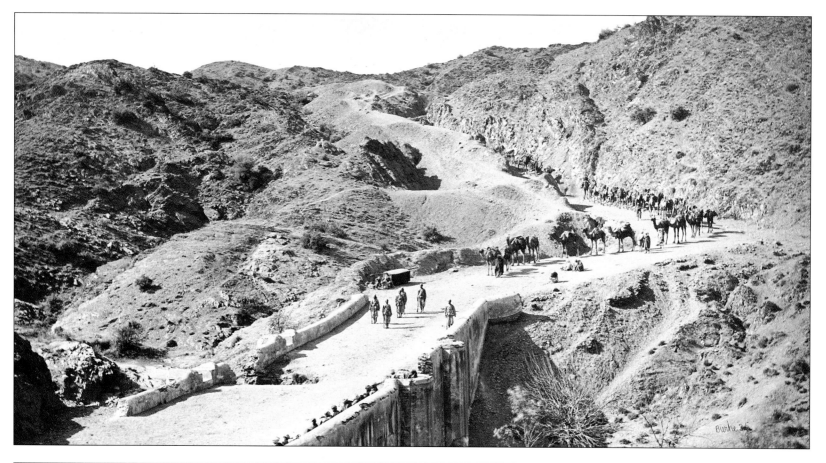

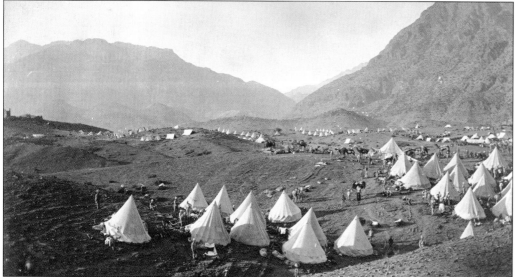

Above: 'Mackeson's bridge and ascent beyond, looking towards Ali Musjid'. The entrance to the Khyber Pass from the Jamrud (i.e. British Indian) side.

Left: 'Shergai Heights looking towards Ali Musjid, showing entire line of enemy's defences right and left of Ali Musjid and camp of the 3rd Brigade.' After the fall of Ali Musjid and the advance along the Khyber, in November-December 1878, the 3rd Brigade remained in garrison on the Shergai Heights.

Right: 'Ali Musjid and camp from Picket on left of Gorge.' The fortress can be seen on the hill, centre left; the Musjid or mosque after which it is named is visible as a small white monument in the centre of the photograph, at the foot of the hill. The camp is that of part of the 4th Brigade.

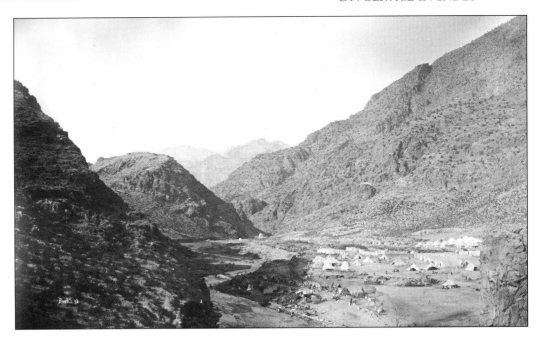

Below: 'General view from Ali Musjid looking back towards Peshawar, showing the whole of the Khyber and the country operated over by the troops.' This shot shows how far the Afghan fort at Ali Musjid dominated the entrance to the Khyber Pass. The camp of the 3rd Brigade is visible on Shergai Ridge and that of the 4th Brigade in the valley below the fort. These two brigades were eventually united as a garrison force for the area around Ali Musjid.

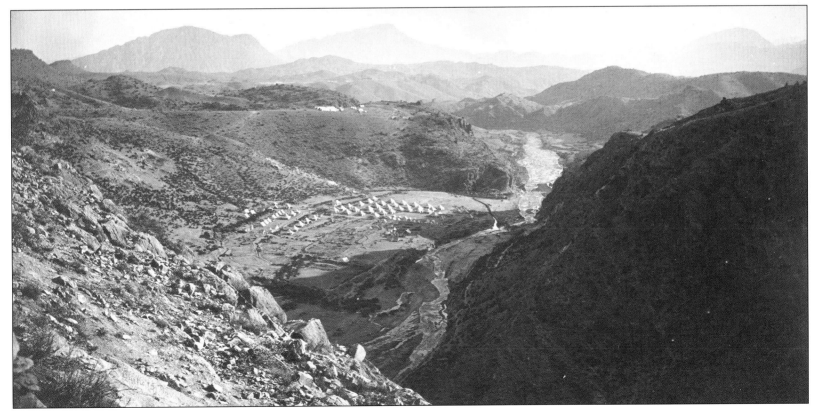

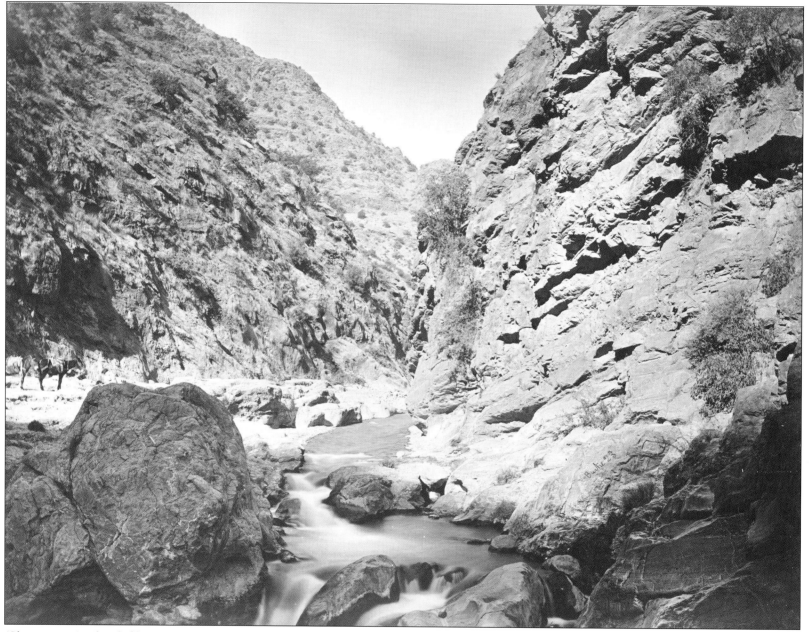

'Sharp turn in the defile, a very tough bit.' This, the narrowest part of the Khyber Pass near Ali Musjid had proved a death trap to forces advancing through the Khyber in earlier times. It was shortly afterwards widened by the Sappers and Miners and the Engineers.

'End of the defile, looking back at Ali Musjid, showing sentry on lower bastion, narrowness of the defile and height of fort above the (Khyber) stream.' Any enemy force dominating defiles such as this could clearly halt an invading army in its tracks.

'Kuta Kushta; the ravine with village in foreground.' A typical fortified mud-walled village, with tower, of the type found in the Khyber and all along the Frontier. Attacks on such villages were a familiar part of Indian frontier warfare and often proved very costly.

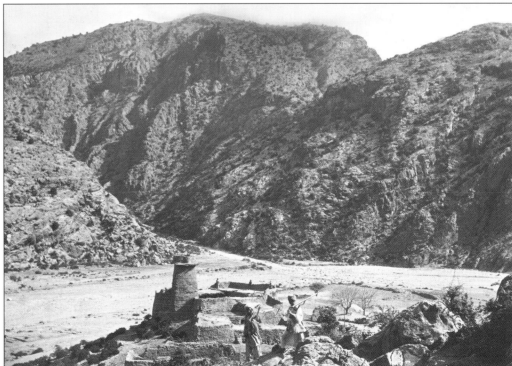

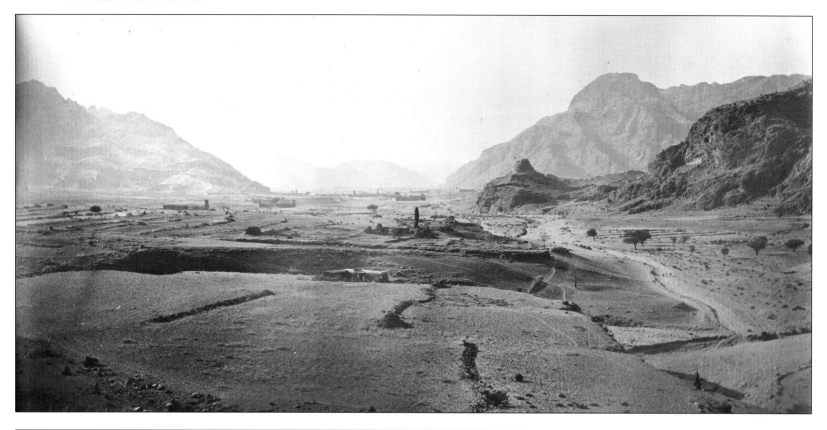

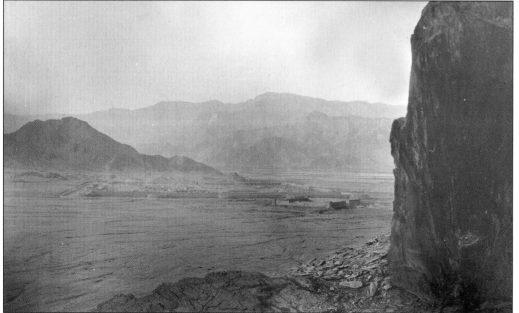

Above: 'General view, Sultan Khel villages and Buddhist topa', in the Khyber Pass. A topa or stupa is a mound raised over some sacred relic of the Buddha. This one – seen centre right – dates from the second century.

Left: 'A view from Conical Hill, near Dakka.' The old fort is seen on the right with the new British camp and fortifications. Dakka remained a major British base throughout the Afghan War.

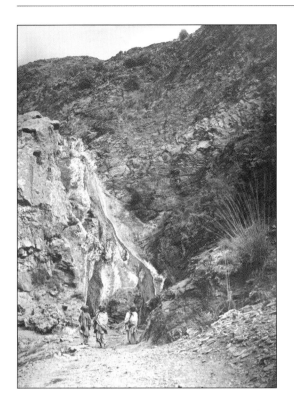

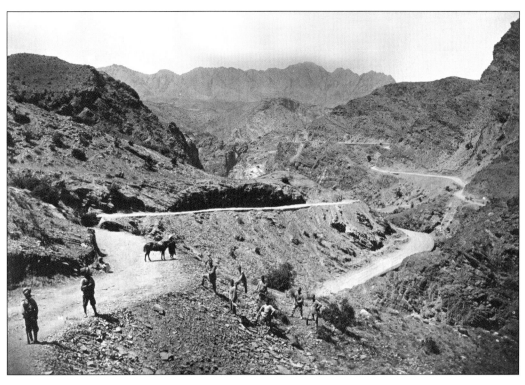

Above: 'The Landi Kotal Pass, above Landi Khana.' Landi Khana was the last major settlement – which became a major military post – in the Khyber Pass before the Afghan border was reached.

Top right: 'Landi Kotal Pass, showing the road made by the Queen's Own Madras Sappers.' Men of the Madras Sappers and Miners are clearly visible on the right, working (or at least posing) with picks and shovels to widen and level the road, which can be seen snaking away into the distance.

Bottom right: 'The river gorge above Lalpura looking towards Bassaule [Basawal].' The 2nd Brigade was based around Dakka and Basawal in December 1878. Both were later used as bases for punitive operations against local tribes.

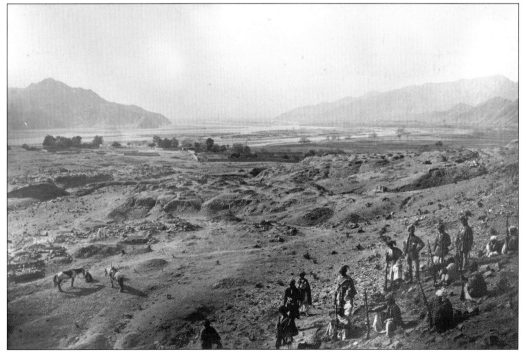

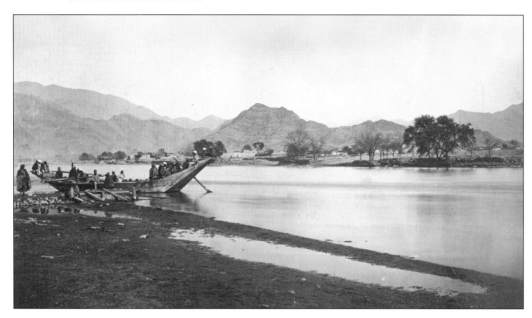

Left: 'Lalpura from the ferry.' Lalpura lies in Mohmand territory; there were to be several British expeditions into the region during the war because of the continuing hostility of the Mohmands. The ferry, with its large and distinctive boats, was referred to by many officers in descriptions of the area.

Below: 'Panorama, Safed Sang camp from 51st Camp, Safed Koh [range] in the distance.' The 51st, King's Own (Yorkshire) Light Infantry, fought at Ali Musjid in November 1878 and took part in the first and

Right: 'Safed Sang, river and old bridge; Sikka Ram peak in the distance.' Safed Sang, thirty miles beyond Jelalabad towards Gandamak, was a dusty, treeless and exposed site but with good water supplies. It too became an important link in the chain of posts stretching from the Khyber to Kabul.

second Bazar Valley expeditions against the Zakka Khel in December 1878 and January 1879. They arrived at Safed Sang on 27 April 1879 and remained there until 5 June 1879 – which helps to date the photograph.

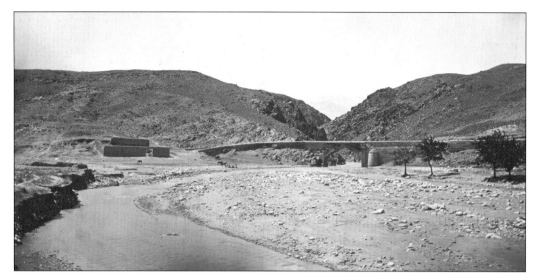

'Surakh-aub, [Surkhab] bridge showing gorge.'

'Midway in the Jug-dulluck [Jagdalak] defile.' Another famous and treacherous pass on the route to Kabul. Held by a determined enemy, such passes could hold up an invading army.

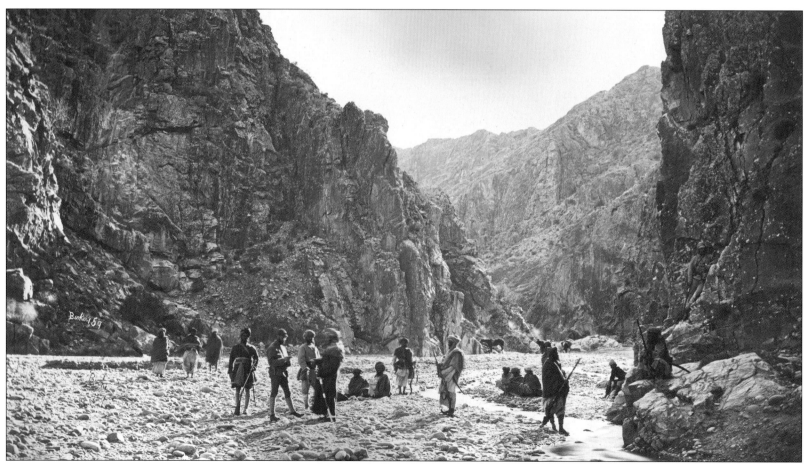

'Entrance to the Jug-dulluck defile, the Parri-Darrah.' The approaches to the Jagdalak defile were strongly garrisoned from 5 November 1879, during the second phase of the Afghan war. The narrowest part of the defile was just eight and a half feet wide.

'Sei Baba [Seh Baba], showing Black Hill.' The British camp, ten miles from Jagdalak, is clearly visible.

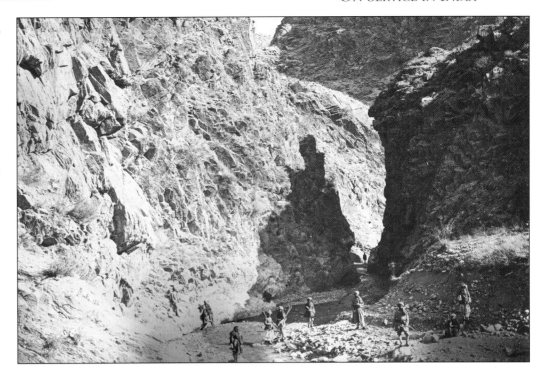

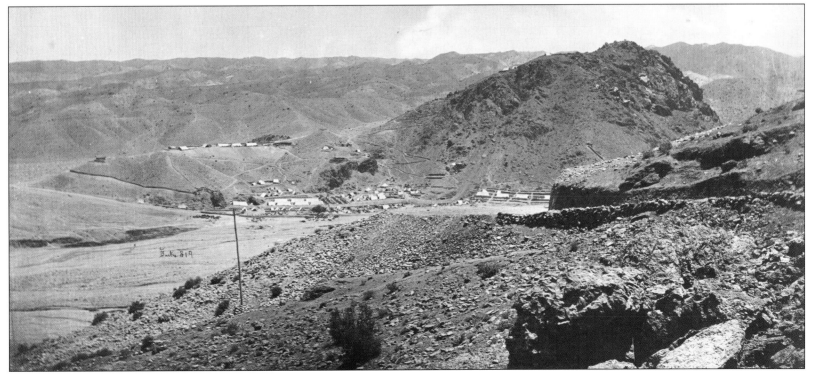

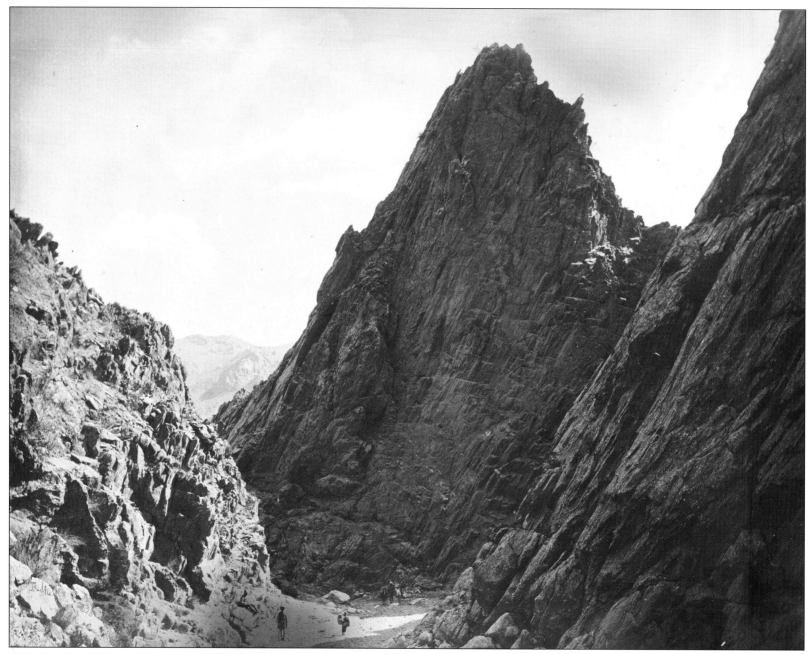

'The Lataband Pass – "the Valley of death".' The Lataband Pass route to Kabul was favoured by Roberts and the pass was considerably widened in places to facilitate the passage of convoys.

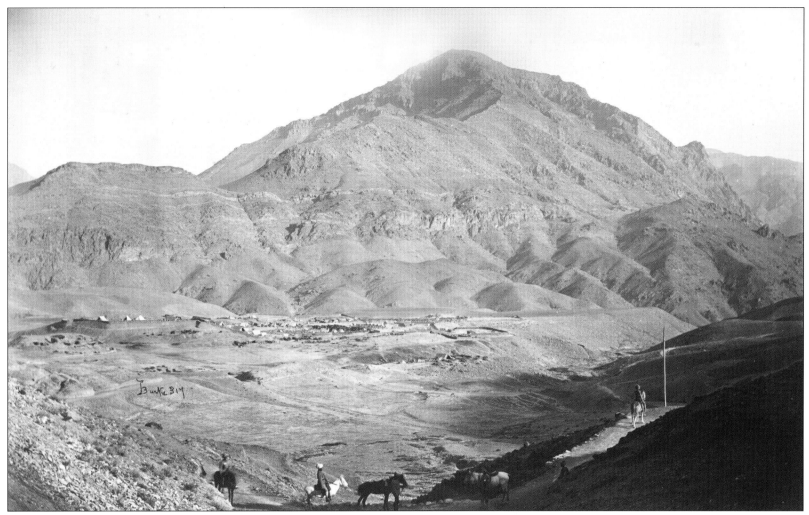

'Lataband camp and Heliograph Hill.' This camp, twenty-five miles from Kabul, was a vital link in Roberts' supply route to Peshawar. During the siege of Kabul, it was garrisoned by Colonel Hudson with the 28th Punjabis, part of the 23rd Pioneers and two guns. It was attacked on 16 December 1879 by a force of 1,000 Safis. The troops here suffered severely from cold and a shortage of food during the winter of 1879. The garrison was picked up by Brig.-Gen. Charles Gough's Brigade en route to the relief of Roberts at Sherpur and arrived at Kabul on 24 December, the day after Roberts had finally dispersed his Afghan besiegers.

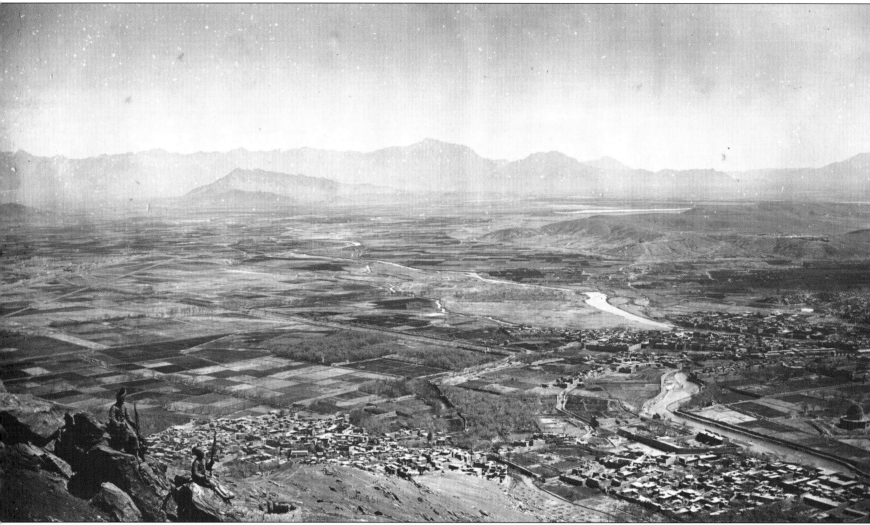

'Panorama from Asmai Fort, looking towards Bhutkhak. Extensive view embracing the whole country from Sherpur to [the] west end [of the] Chardeh Valley.' This superb panorama shows part of the city of Kabul, with the great fortress of the Bala Hissar to the centre-right and, in the distance, the Chardeh Valley, where some heavy fghting took place in December 1879 as the British struggled to hold Kabul, the key to northern Afghanistan.

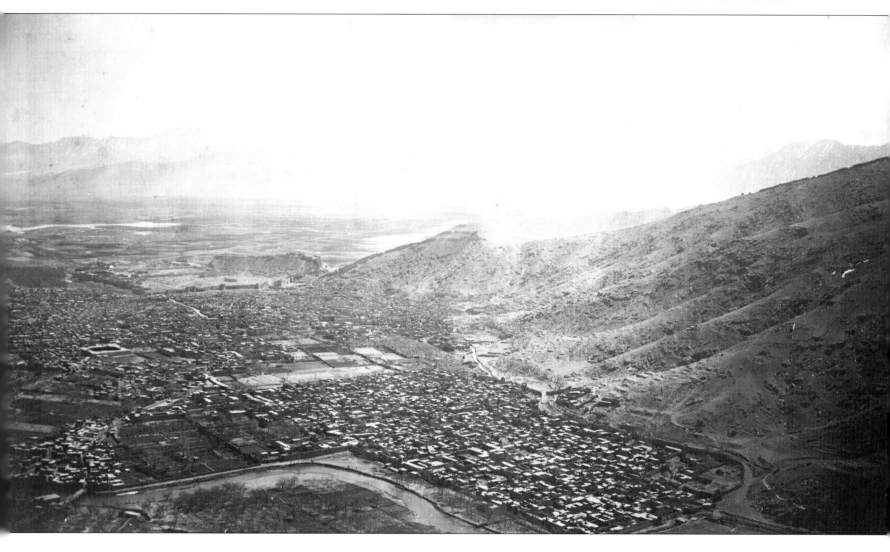

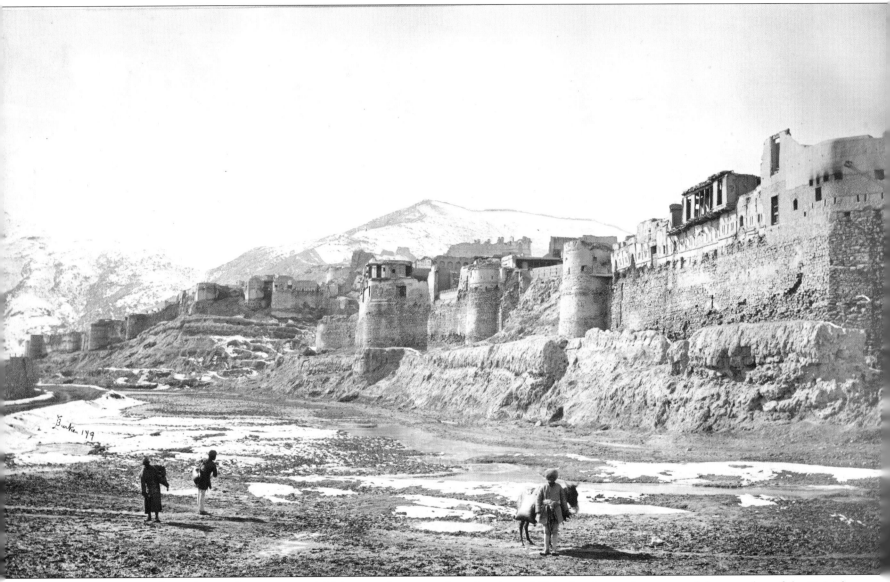

'The Bala Hissar from the south-east corner.' This great fortress-palace dominated Kabul and was the scene of the murder of the British resident, Sir Louis Cavagnari and his escort on 3 September 1879. For a short time it was the main camp of the force under Roberts until the troops moved into the extensive cantonment at Sherpur on the outskirts of the city. Large areas of the Bala Hissar were destroyed by an ammunition explosion on 16 October 1879 and by deliberate slighting by Roberts. To the right British soldiers pose at one of its great gateways.

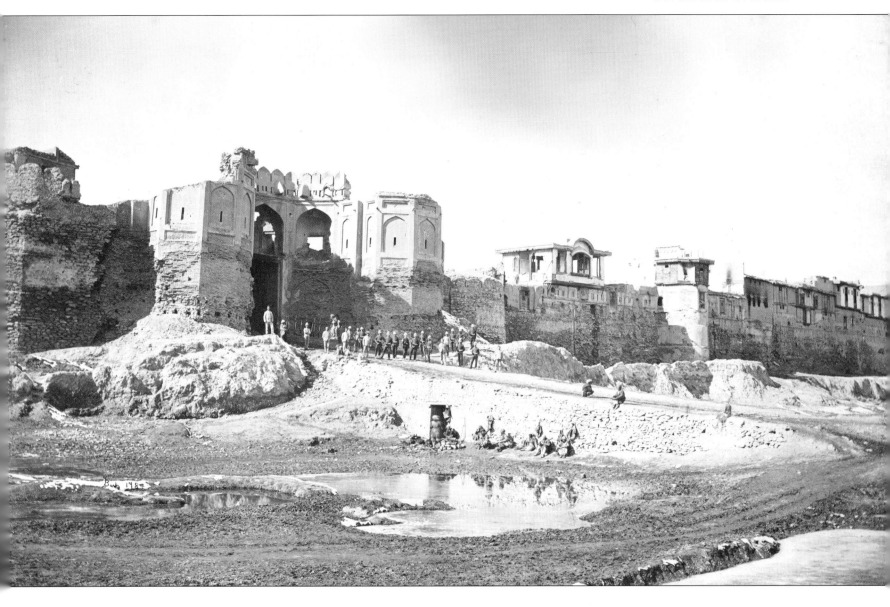

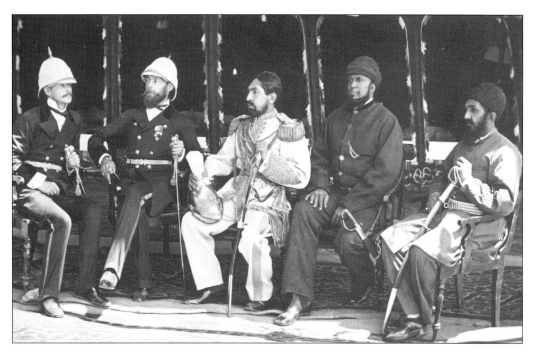

The Embassy to Kabul. Burke's famous photograph of Sir Loius Cavagnari (second from left) and his Politcal Officer, Mr Jenkyns of the Civil Service, with the Emir Yakub Khan (centre), General Daud Shah and the Mustaufi Habibullah Khan. The massacre of Sir Louis, his staff and his escort of the Corps of Guides brought about the renewal of hostilities in September 1879 and the second British invasion.

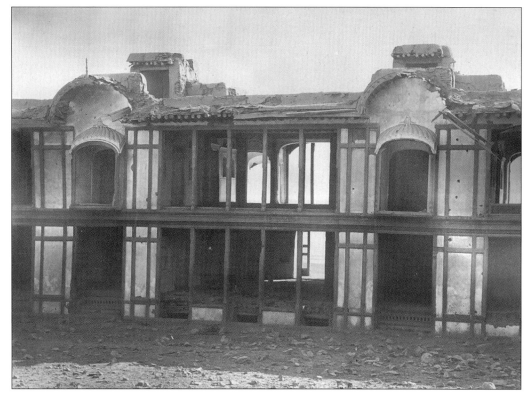

The front view of part of the Residency in the Bala Hissar where Cavagnari and his escort of Guides was killed. The fire damage and bullet holes are clearly visible. The small escort of Queen Victoria's Own Corps of Guides under Lt 'Wally' Hamilton VC, put up a desperate but futile resistance. A fine memorial archway to the Guides killed here still stands in Mardan.

The rear view of the Residency – backing onto the outer ramparts of the Bala Hissar. It was reduced to ruins during the attack on Cavagnari and his escort in September 1879.

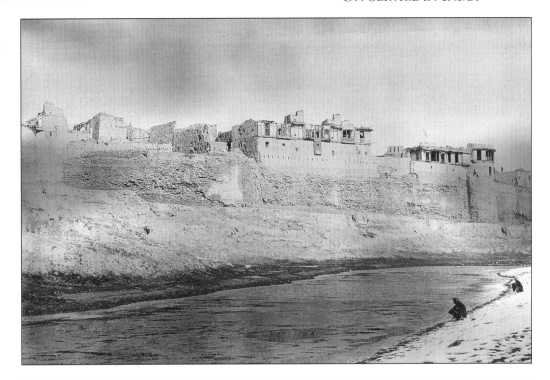

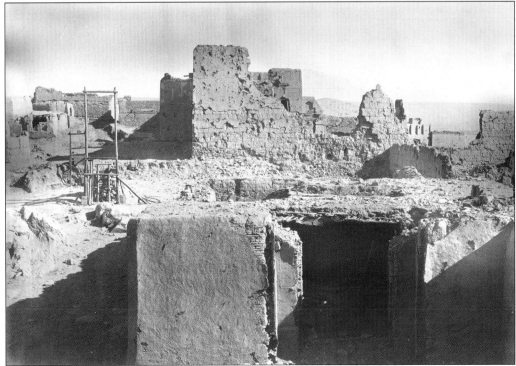

'Ruins of the Residency where Cavagnari and his escort were killed.' Note the scaffold to the left where some much-criticized summary punishment was meted out by Roberts.

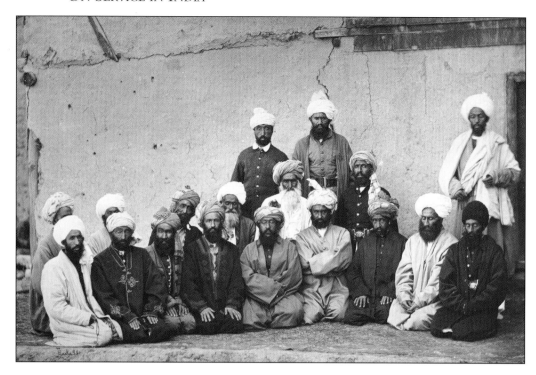

'Sirdar Habibulla Khan Ghilzai and other Khans.' Habibullah Khan (in the row kneeling, fourth from right) the Mustaufi or Finance Minister to the Emir Yakub Khan, was widely believed by the British to have been implicated in the attack on the Residency and murder of Cavagnari. He was detained and interrogated by a military tribunal in Kabul but no conclusive evidence was found and he was allowed to remain in Kabul, occasionally under guard. He was mainly used by the British as an intermediary in their negotiations.

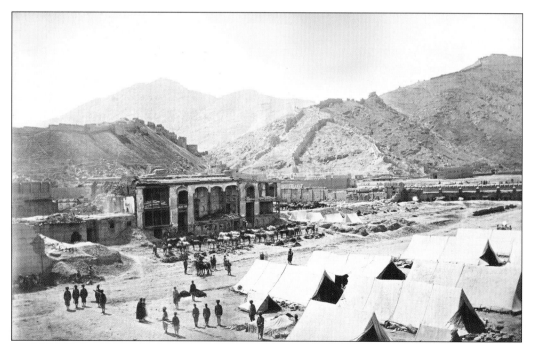

'The Dewan-i-Aum in the Bala Hissar, showing Bala Burj and Sherderwaza [Heights].' The Dewan-i-Aum was the former Public Audience Chamber of the Palace. The Sher Darwaza Heights – as with most of the heights overlooking Kabul – were the scene of considerable fighting, especially on 12, 13 and 14 December 1879. The Bala Burj (background, left) was the principal citadel of the Bala Hissar.

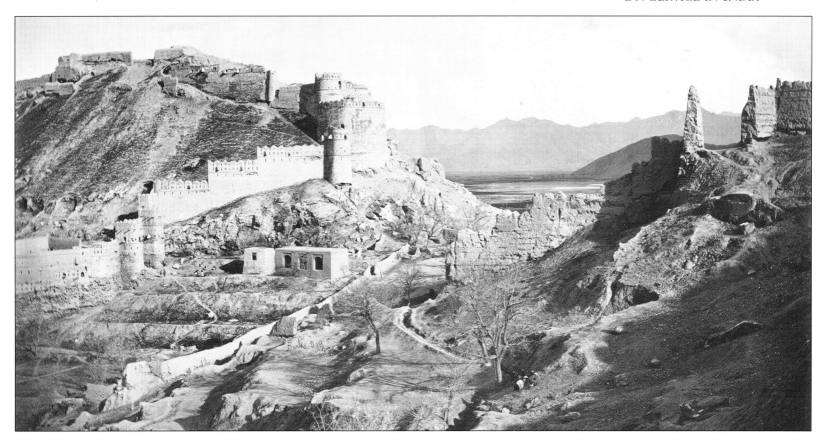

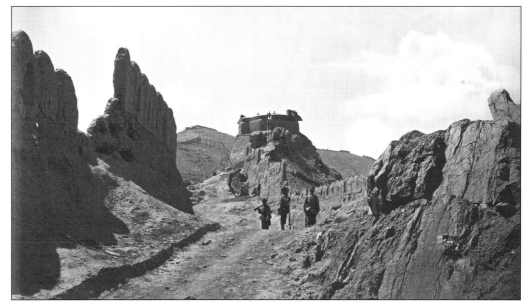

Above: 'Gap between Upper Bala Hissar and Bala Burj, looking towards Beni Hissar.' The area around Beni Hissar was the scene of heavy fighting on the 13 December 1879 when it was cleared by the 92nd Highlanders after they had seized the Takht-i-Shah heights.

Right: 'Going up to the Bala Burj.' The Bala Burj was the main citadel within the fortress of the Bala Hissar. Note the newly-constructed block-house on the rocky outcrop.

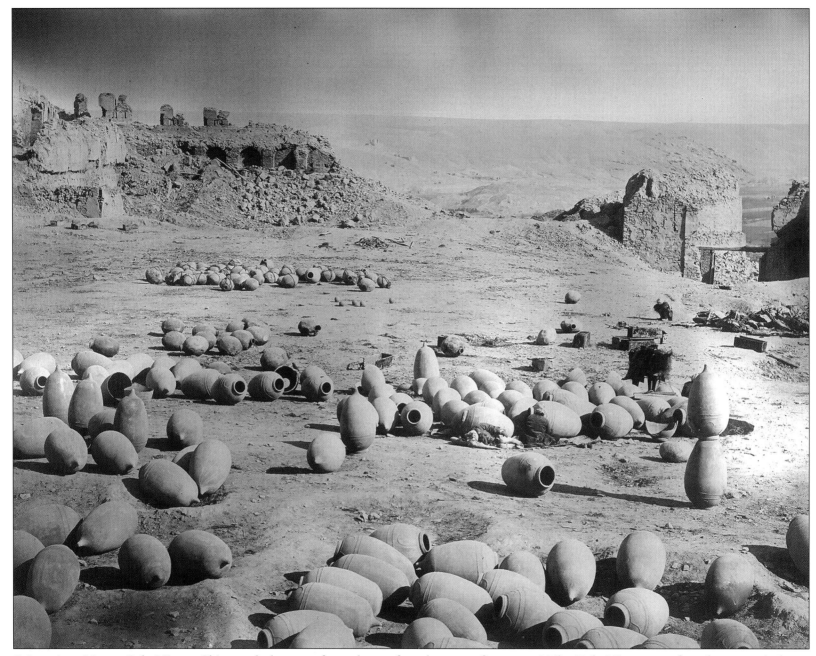

'Magazine, Upper Bala Hissar: Skins and gharrus of powder, as found on our first entry.' The Bala Hissar was found to contain huge quantities of ammunition and powder. On 16 October 1879, two violent explosions occurred in the magazine, shaking the city and killing the Ordnance Officer, Lt E.D. Shafto RA (who was supervizing the clearance of the stores) and twenty-one soldiers and helpers. The explosions helped convince Roberts of the need to move his garrison beyond the city to the cantonments at Sherpur.

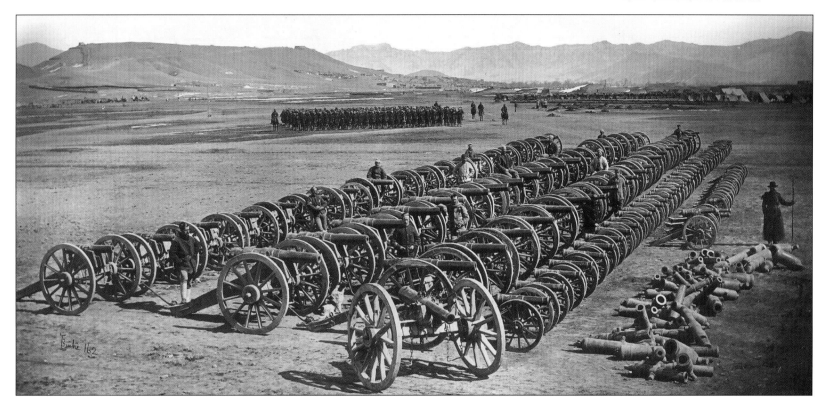

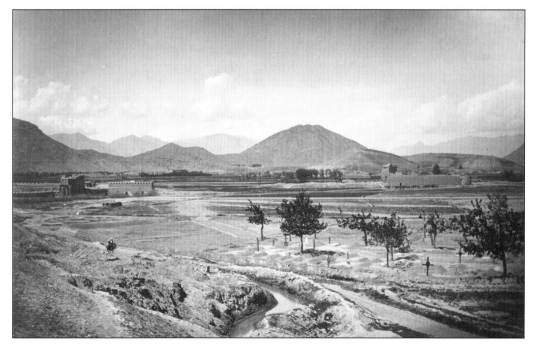

Above: The Afghan ordnance captured at Kabul. A large variety of guns – some Russian – is shown in Burke's photograph. In the background, the 5th Punjab Infantry are in quarter column. In the distance (left) are the Bemaru Heights, with Fort Onslow crowning the right of the ridge. Colonel Mitford recalled that one of the captured guns was so highly polished that one Highlander was convinved that it was made of gold.

Right: 'The cemetery from west end, Bemaru, showing Alibad [Aliabad] Kotal and hills around.' Nothing remains of the small British cemetery here (centre right) – nor of any other British cemetery in Kabul. The Kotal crosses the Asmai heights and was later connected to Sherpur cantonment by a new road.

Left: 'Bit of the Road in Dehmazang Gorge.' The main road southwards from Kabul to Ghazni ran through this pass in the Asmai ridge. There was heavy fighting in this area in December 1879. The gorge gives access to the Chardeh plain.

Below: 'Besutee Hazara Chiefs.' The third largest ethnic group in Afghanistan, the Bezoti Hazaras were an agricultural people living in the central region of Afghanistan, west of Kabul. They seem to have played little part in the warfare against the British.

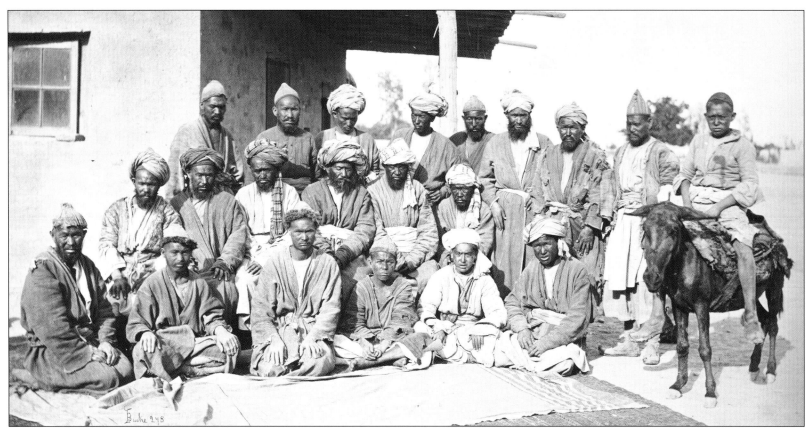

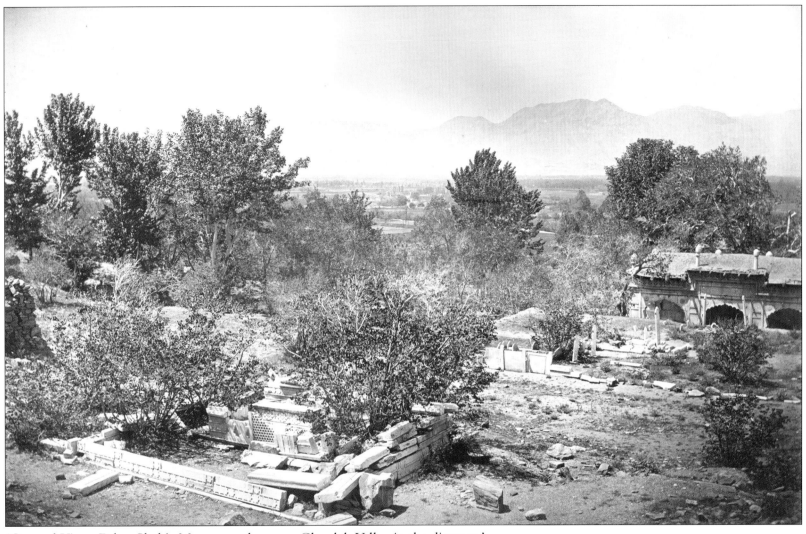

'General View: Baber Shah's Mosque and graves; Chardeh Valley in the distance.'

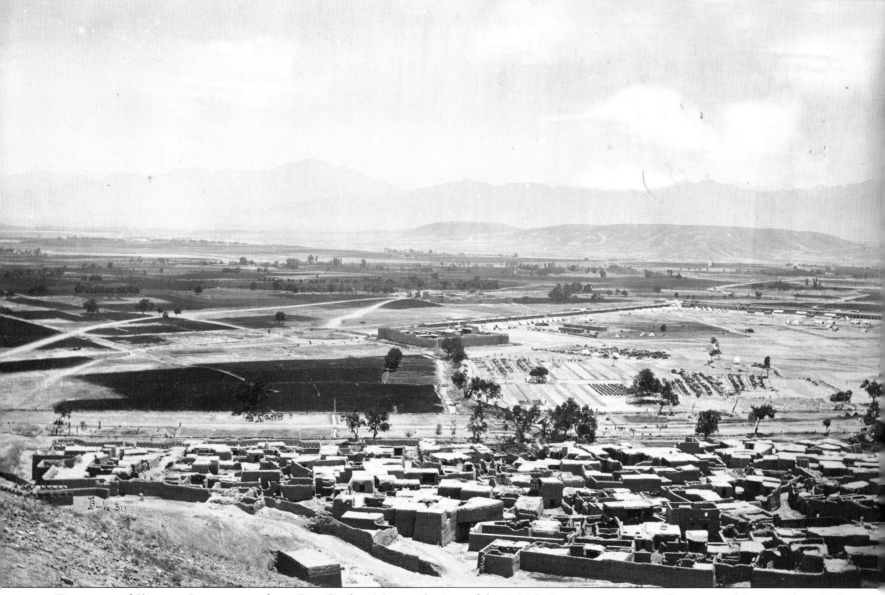

'Panorama of Sherpur Cantonment from Fort Onslow.' A superb view of the British Cantonment, taken from one of the new forts built on the Bemaru heights, which formed the northern defence line of Roberts' encampment. The village of Bemaru, foreground left, was incorporated into the defensive system.

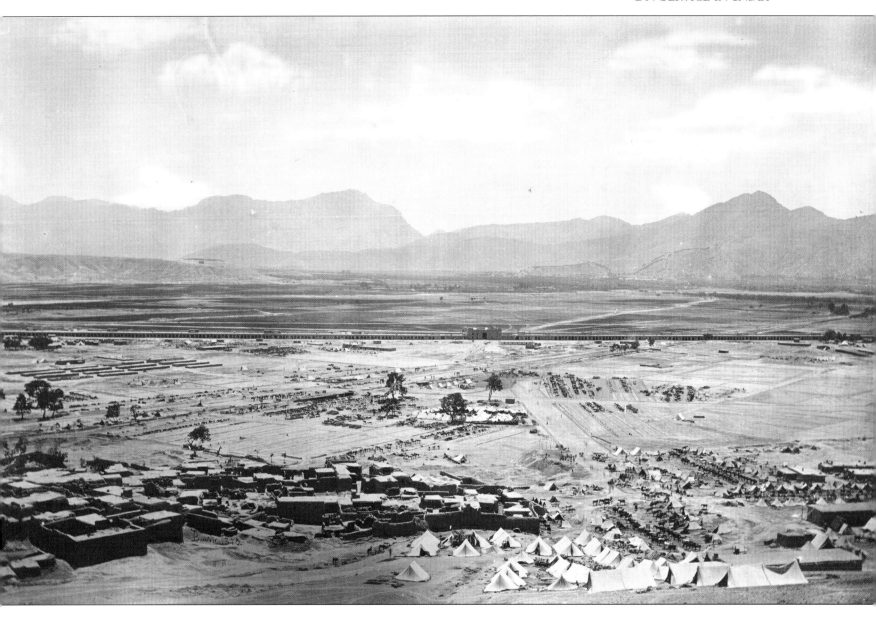

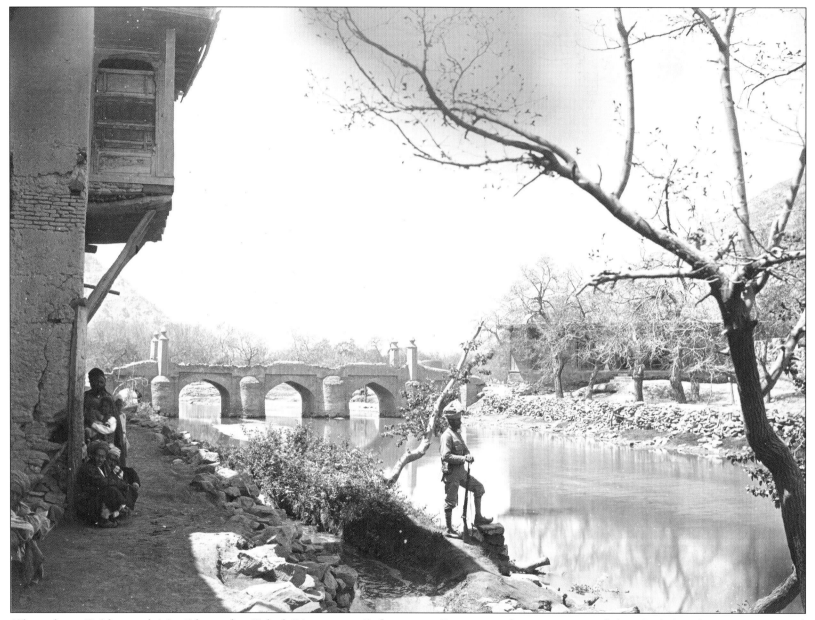

'Shamshere Bridge and Musjid on the Kabul River, near Dehmazang Gorge, northwest corner of the city.' Another evocative and carefully-posed Burke photograph, with a Pathan soldier in the foreground.

A group photograph of the 5th Punjab Infantry, 1880. This superbly-posed and characterful study by John Burke shows, left to right, back row: -?-; Surgn Simmonds; Jem. Buish Singh (Sikh); Jem. Surmust (Afridi). Middle row: Jem. Sham Singh (Sikh); Capt. C.M. Hall; Lt Jameson; Maj. Pratt (with cane); Lt J.E. Mein (bearded); Lt Orr. Front row, on ground: Sub. Baz Gul; Sub. Yooma (Afridi); Sepoy Balu (Afridi); Maj. Pratt. These were the members of the 2nd Sikhs, commanded the 5th Punjabis from 5 October 1879 to 25 April 1880. Lt C.J. Orr, attached from the 3rd Infantry, Hyderabad Contingent, joined the 5th at Kabul in January 1880.

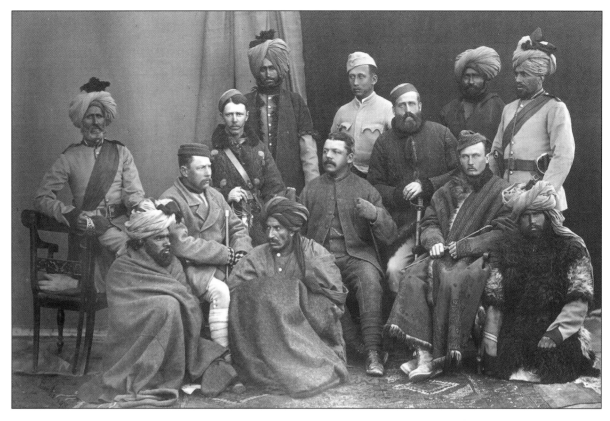

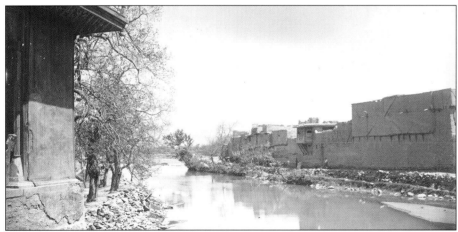

Above: 'View down Kabul river from Shamshere Bridge, showing city.'

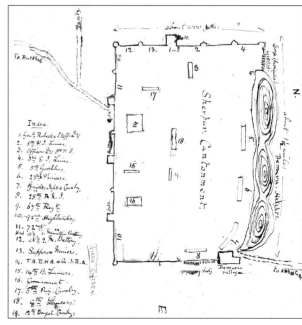

Right: J.E. Mein's sketch of the Sherpur cantonment showing the location of the military units based at Kabul and which were besieged in Sherpur in December 1879.

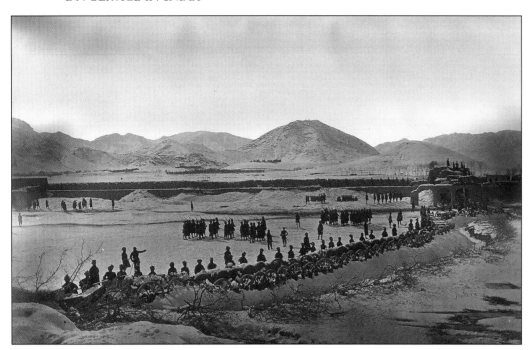

Burke's famous view of the corner of the Sherpur cantonment manned by the 5th Punjab Infantry, 23 December 1879, 'the gun-wheel defences hastily constructed'. J.E. Mein is the officer in the bottom left, pointing. He noted that 'this parapet and one quarter mile more than is seen here was manned by the 5th Punjab Infantry from Dec. 14th to 23rd'.

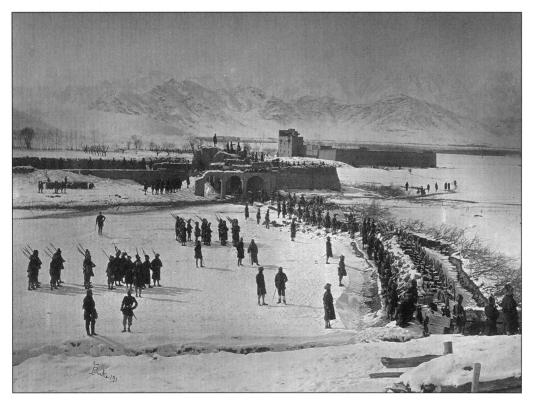

The same area of Sherpur, photographed by Burke from another angle and with the groups of men placed differently. J.E. Mein stands in the centre, leaning on a cane. His note says that he slept near this spot every night from 14 to 23 December 1879. The ruins in the centre are of a magazine blown up by the Afghans on 7 October as the British took Kabul.

Officers' quarters of the 5th Punjab Infantry in Sherpur, 'built by men of the Regiment'. J.E. Mein stands in the right foreground (leaning on a cane); next to him is Major Pratt. Officers of the 5th identified near the verandah are, left to right: Maj. Hall (sitting); Surgeon Simmonds (in the light uniform); Lt Welchman; General Vaughan; Lt Orr (sitting); Lt Sparling; Lt Jameson. In the background (left) are limekilns occupied by the officers of the 3rd Sikhs. The Bemaru Heights are in the distance. Lt Welchman, attached from the 1st Infantry, Hyderabad Contingent, joined the 5th at Kabul with Lt Orr, in January 1880.

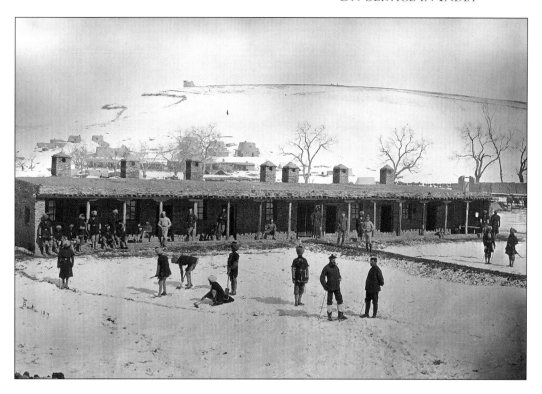

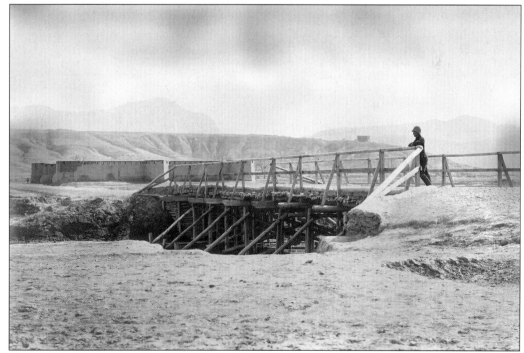

'Fort Ibrahim Khan, garrisoned by 100 rifles, British Infantry, to keep a guard over the bridge [over the Kabul River] and an open communication between Sherpur and Siah Sang along our new military road.' Note the new blockhouse in middle distance, right, on the Siah Sang Heights.

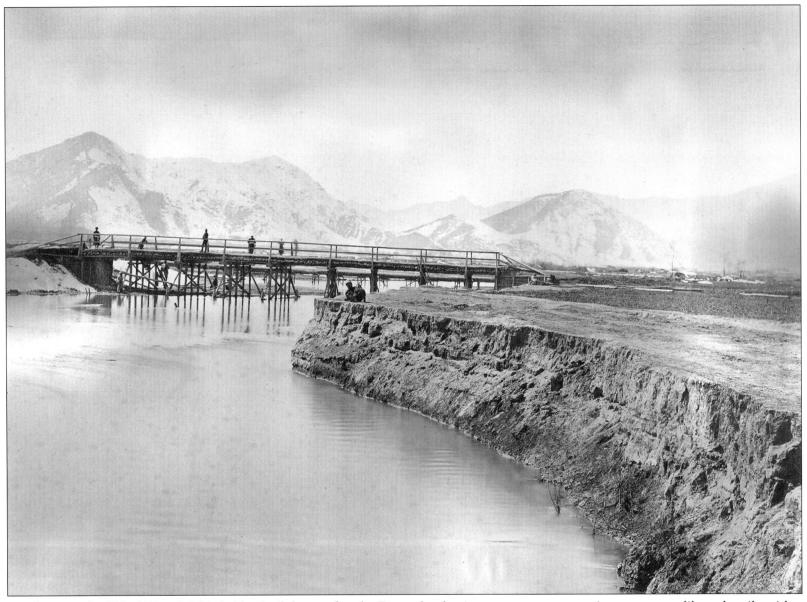

'Bridge over the Kabul River.' 'This bridge built by us after the December business so as to communicate more readily and easily with the Bala Hissar from Sherpur cantonments. The bridge practicable for all arms [i.e. infantry, cavalry and artillery].'

Far right: John Edmund Mein wearing his India General Service medal, clasp 'Jowaki 1877-8' and Afghan War medal, clasp 'Kabul'.

Right: Souvenirs of war. On the left is a key to a store-room at Beni Hissar, taken by an officer of the 92nd when the village was attacked on 13 December 1879. Given to J.E. Mein in the Officer's mess of the 92nd Highlanders in Kabul on Christmas Day 1879 and used by him as a paper-weight thereafter. On the right is a fragment of furniture or a carved fitting taken from the burned Residency at Kabul by J.E. Mein.

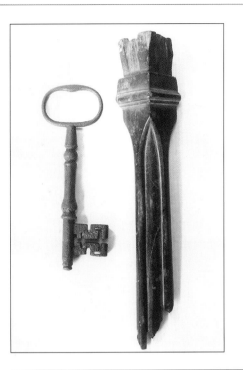
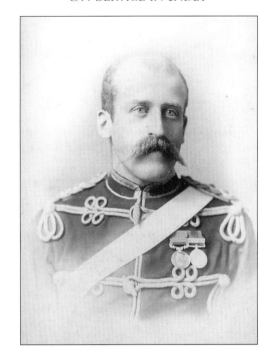

Army Signalling Class, Rurki, 3 March 1880 to 26 April 1880. F.B. Mein following in his brother's footsteps. Left to right, back row: Lushington; Hyslop (17th); Farquhar (18th Hussars); Strong (90th Regiment); Grubbe (88th Regiment); F.B. Mein (63rd Regiment). Middle row: Stewart (5th Regiment); O'Brien (30th Regiment); Lamb (40th Regiment); Mockler (6th Regiment); Morris (81st Regiment), Weyland (Rifle Brigade). Front row: Sealy (22nd Regiment); Clough-Taylor (88th Regiment); Blunt (RE); Kenyon-Slaney (Grenadier Guards); Hamilton (100th Regiment).

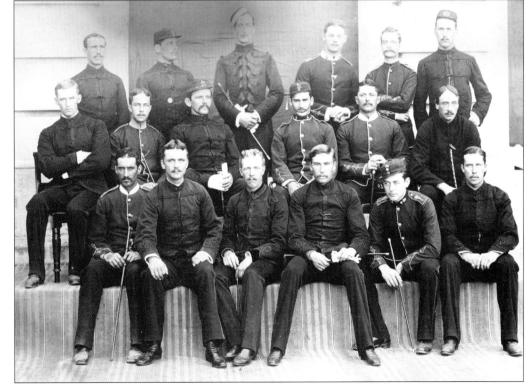

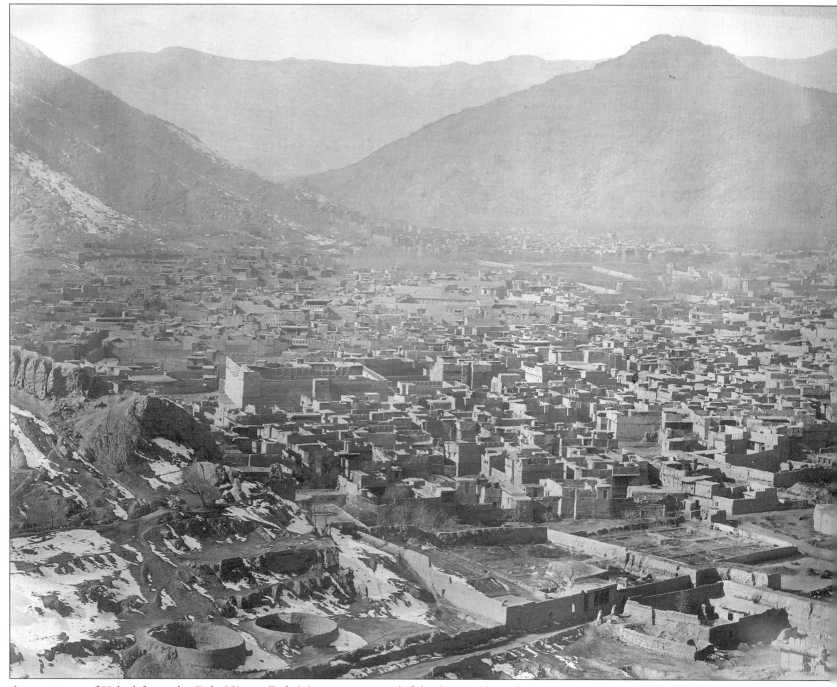

A panorama of Kabul from the Bala Hissar. Deh Mazang gorge to left background, with the Asmai heights – the scene of heavy fighting on 14 December – dominating the city (centre background). To the front left is the Kazalbash or Persian Quarter of the city and Sherpur lies to the right just beyond the city limits.

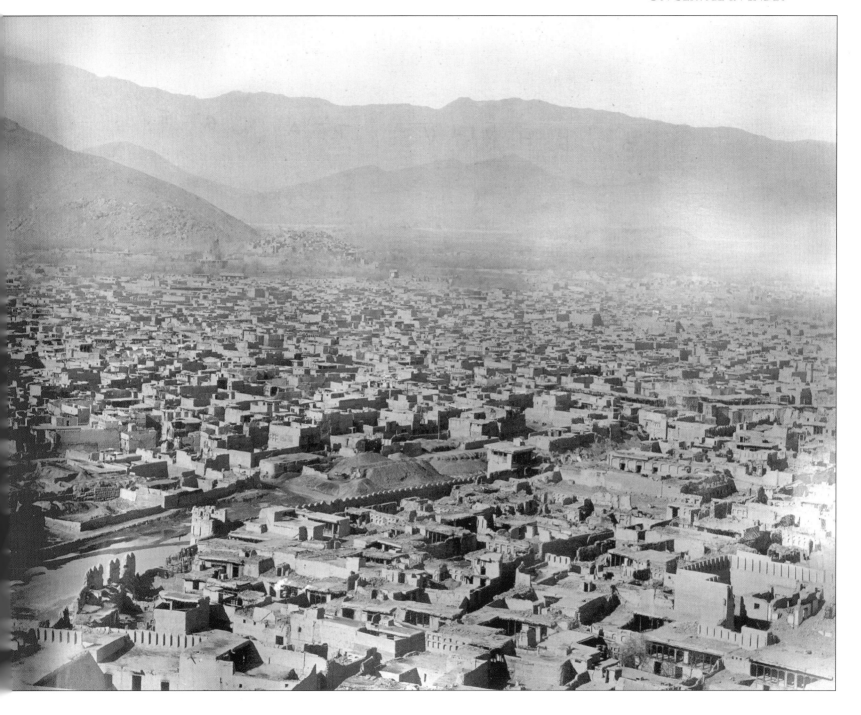

This is to Certify that *Lieut. F. B. Mein, 5ᵗʰ Punjab Infantry* has passed in *Hindustani* according to the Higher Standard as laid down in Rules V. and VI. of the General Order by the Government of India, No. 734, dated the 9th September 1864, before the Civil and Military Examination Committee assembled at Bombay on the *6 & 15 Novʳ* 1882.

President of the Civil and Military
Examination Committee.

Bombay,
16 Novʳ 1882.

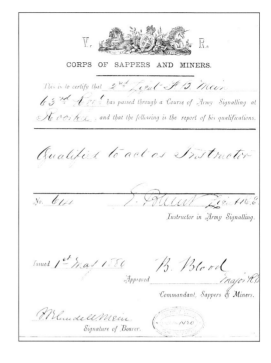

CORPS OF SAPPERS AND MINERS.

Above: F.B. Mein's certificate in Army Signalling, 1880.

Top left: F.B. Mein's certificate in Higher Standard Hindustani, 1880. All officers had to pass basic examinations in a relevant native language (e.g. Hindi, Urdu, Pushtu, Tamil) before they could be finally accepted into the Indian army.

Bottom left: Colour Party of the 63rd Regiment, Sialkot, 1882. Left to right: Col.-Sgt Jones; Col.-Sgt Mulcaster; Sgt Lloyd; Sgt Wainwright. Seated: Lt Quinn; Lt Dawson.

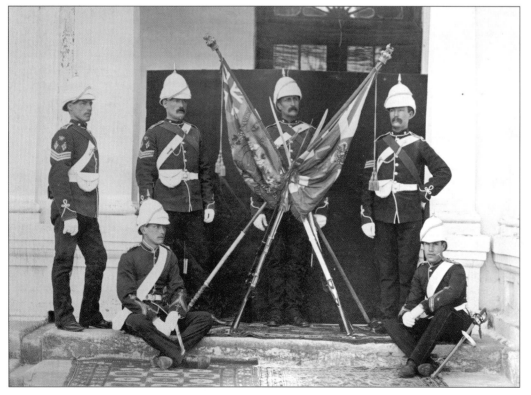

Right: Headquarter Wing, the 63rd Regiment, at Sialkot, 1883. The officers are mounted; the Colours in the front rank, centre, and the Band to the right.

Below: Officers of the 63rd Regiment, Sialkot, 1883. Left to right, back row, standing: Lt Quinn; Lt Ternan; Maj. Studdy; Lt-Col. Auchinleck. Middle row: Maj. Jackson; Lt Stubbs; Lt Dawson; Lt and Adjt Smith; Surgn.-Maj. O'Halloran. Front row: Maj. N.X. Gwynne; QMS D. White; Capt. Cook; Lt Lang; Maj. Russell Jones.

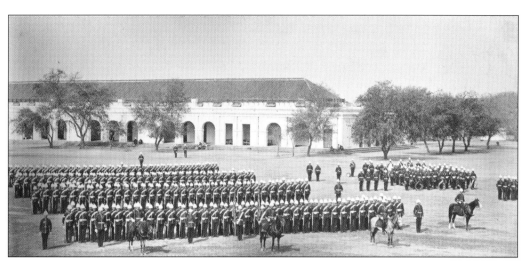

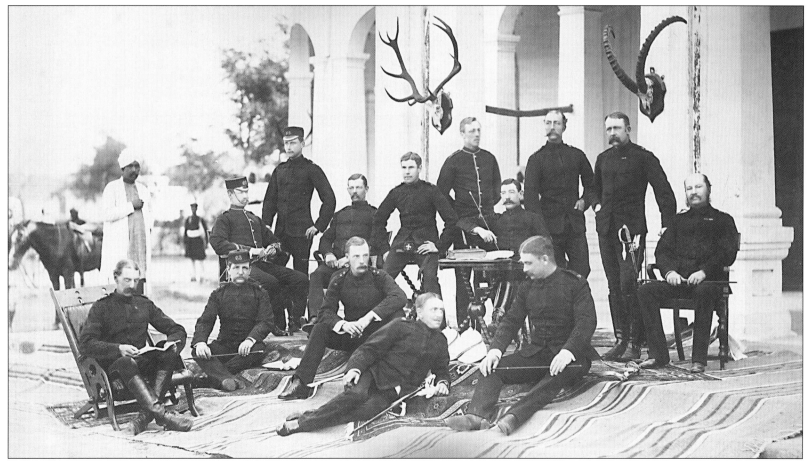

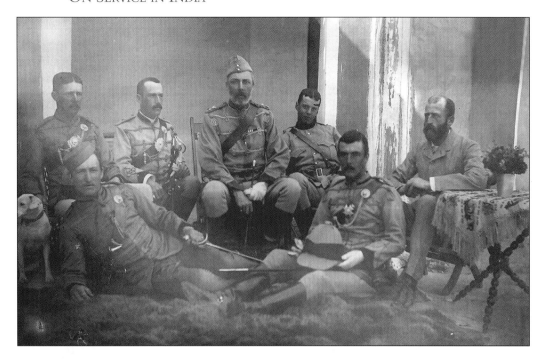

PUSHTO EXAMINATION, 18⁸³.
(Lower Standard.)

Report of the Sub-Committee of Examination assembled at Dera Ismail Khan,
Oct 29ᵗʰ 1883.

THE Examination of *Lieutt Mein*
5ᵗʰ P.I.

Number of Marks.

I.—Reading and construing ... (100) ... *85*
II.—Conversation ... (100) ... *55*

TOTAL ... (200) ... *140*

We, the undersigned, do hereby declare that the above is a fair and impartial report of the examination of the above-named Candidate, and that he has *passed* the prescribed examination in the Lower Standard of Pushto.

President.
Member. SUB-COMMITTEE.
Member.
Confirmed and countersigned.

_____ , President.
_____ , Member.
_____ , Member. CENTRAL COMMITTEE.
_____ , Member.

Peshawar, _____ 18 .

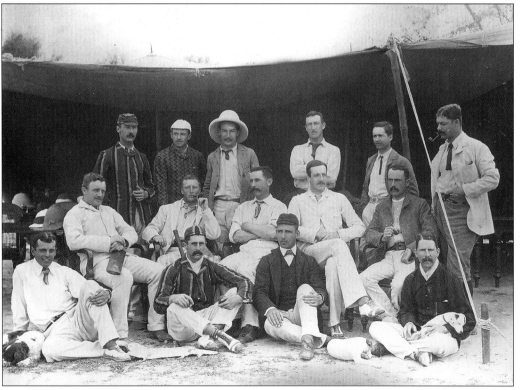

Above: F.B. Mein's certificate in Pushtu, 1883. Pushtu was the main language of the frontier tribes – and of many men of the Punjab Frontier Force who were drawn from those tribes.

Top left: Officers of the 5th Punjab Infantry. Left to right, back row: Jameson; F.B. Mein; McKinnon; Eales; J.E. Mein. Front row: Johnstone; Cooper.

Bottom left: A mixed group of officers in sporting attire. Left to right, back row: Taylor (6th Punjabis); Drake-Brockman (RA); Orr (Public Works Department); Johnstone (5th Punjabis); Bowen (Medical Department); Leigh (Army Chaplain). Middle row: Erskine (6th Punjabis); Baynes (RA); Bookey (Medical Department); Robertson (Public Works Department); F.B. Mein (5th Punjabis). Front row: Eales (5th Punjabis); Birch (RA); Murray (1st Pun Cav); Western (1st Pun Cav).

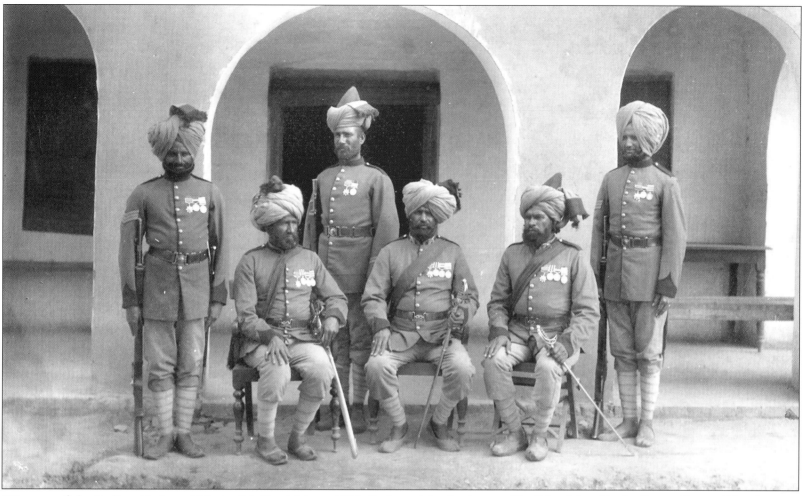

Winners of the Indian Order of Merit, 5th Punjabis, *c.* 1883. Left to right, back row: Havildar Man Singh; Sepoy Omer; Hav. Sarwan Singh. Front row, seated: Subadar Rahman Khan; Subadar Budh Singh; Subadar Baz Ghul.

Instituted in 1837, the three classes of the Indian Order of Merit were the highest awards for gallantry which could be awarded to Indian soldiers prior to 1912. The Order was highly prized and respected. Of the soldiers shown here, Subadar Rahman Khan was awarded the IOM for gallantry during the Indian Mutiny campaign. Subadar Budh Singh was admitted to the 3rd Class by GGO (Government General Order) 1260 of 1879 for conspicuous gallantry at Charasiah on 6 October 1879, when he led 'A' Company in a frontal attack on the central Afghan position on the heights at a critical juncture in the battle. Sepoy Umra, Naik Surwan Singh, Subadar Baz Ghul and Sepoy Man Singh were admitted to the 3rd Class by GGO 252 of 23 April 1880, for gallantry in action in the fighting round Kabul between 10 and 23 December 1879. Sarwan Singh's award was for his part in the rearguard action fought under Lt Sparling with General Baker's column moving into in the Argandeh valley on 11 December. Sepoy Umra, Man Singh and Baz Ghul gained their awards for the storming of a serai (a walled garden) near Kabul during General Baker's operations on 13 December. There were at least five other awards of the IOM to the regiment for the Afghan war.

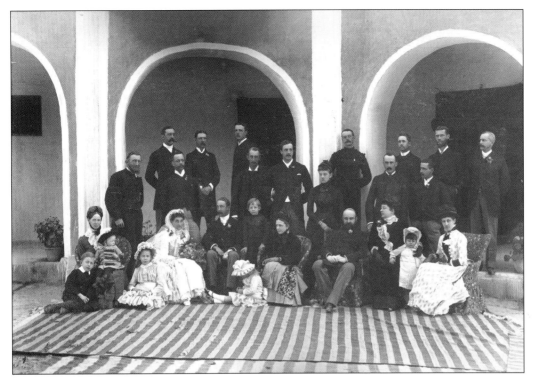
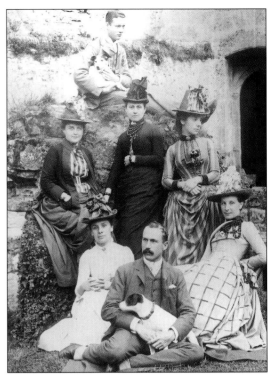

Left: Bridal Party, Bannu, *c.* 1883. Left to right, back row, standing: E.W. Cunliffe (6th Punjabis); Jameson (5th Punjabis); Egerton (5th Punjabis); Shaw (1st Pun.Cav.), in uniform; Bowen (Medical Department); Parkes (Public Works Department); Bruce (6th Punjabis). Middle row: Revd Mayer; Barrett (Public Works Department); Minchin (6th Punjabis); Robertson (Public Works Department); Mrs Cunliffe; F.B. Mein (5th Punjabis); Farley (Public Works Department). Front row: Mrs Mayer; Mrs Bean (bride); Bean (Public Works Department); Mrs McKinnon; Connolly (District Commissioner); Mrs King; Mrs Birch. The children are not known.

Right: F.B. Mein on leave: at Bodiam Castle with friends, *c.* 1887-88, ... and with the obligatory dogs, in this case Shah (top) and Major.

The Takht-i-Suleiman Expedition, 1883

This expedition was a purely scientific venture designed to map and survey the remote area round the Takht-i-Suleiman mountain in Sherani territory. Any military interest centred on the fact that the peaks of the Takht commanded fine views over the area to the west and of the hills near the Quetta-Kandahar road. The local people having offered no objection, the 5th Punjabis (then at Dera Ismail Khan) joined a column assembling at Draband under Brig.General Kennedy. The troops selected were the 4th and 5th Punjab Infantry, the 1st Sikhs, forty-two men of the 1st Punjab Cavalry and No. 4 Mountain Battery. The force crossed the border on 18 November 1883 and marched to Kach Mazrai, encountering some very difficult terrain. As it soon became apparent that opposition would be encountered from the Khidarzai clan, Kennedy divided his troops into two smaller columns which fought their way over the Pezai Pass on 26 November and dispersed the enemy gathering with some loss to both sides. With the bulk of the force camped around the Pezai springs, the actual survey of the peaks under Maj. Holdich RE (with a small escort) went on uninterrupted. On 2 December the column began its return march and crossed the frontier on the 6 December. The 5th Punjabis returned to Dera Ismail Khan on 8 December at the end of a brief, successful but arduous expedition.

The Takht-i-Suleiman Expedition, 15 November 1883-8 December 1883. At the front, left to right: Cooper; Griesbach; Robinson (Medical Department), with sword; Macleane (1st Pun.Cav.), with white helmet; Holdich RE; Stewart (1st Punjab Cavalry); O'Mealy (1st Pun.Cav.); Cruickshank; Gartside-Tipping (1st Bengal Cavalry, Intelligence Officer).

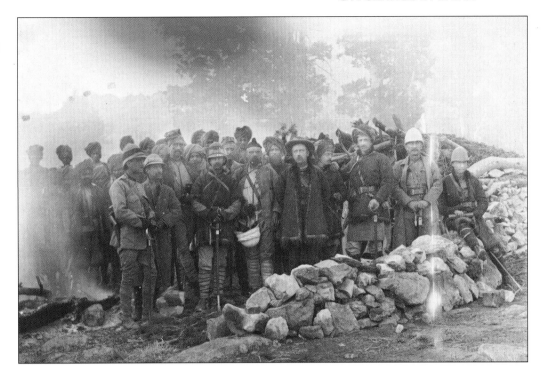

Officers on the Takht-i-Suleiman Expedition. Left to right, back row: Lt Stewart (1st Pun.Cav.); Capt O'Mealy (1st Pun.Cav.); Col. Macleane; Capt. Radford (4th Punjabis). Front row: General Kennedy; Major Shepherd, Brigade Major. Note the wearing of *poshteens* (frontier or Afghan leather coats with the fleece on the inside).

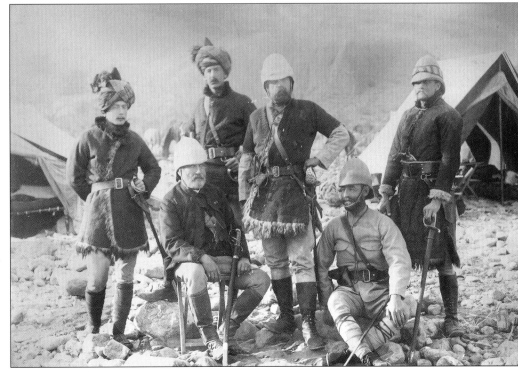

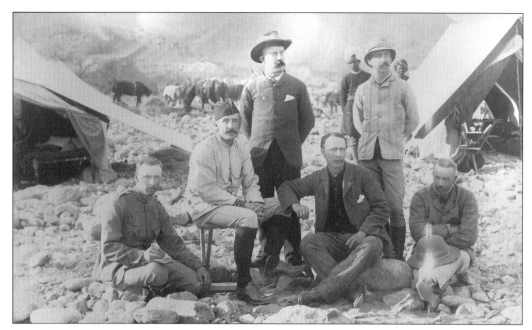

Top left: Officers on the Takht-i-Suleiman Expedition. Left to right: Lt Gartside-Tipping (1st Bengal Cav, Intelligence Department); Col. Cruickshank RE, seated; Maj. Holdich RE; S. Thorburn (Deputy Commissioner); Mr Griesbach; Mr Coxwell.

Bottom left: F.B. Mein's House servants, 1883-84. 'Mohammedan Servant Elahi Bakhsh and family.'

Below: Part of F.B. Mein's Certificate 'Mentioning' his services on the Takht-i-Suleiman Expedition. F.B. Mein's services were recognized by a 'mention' in official dispatches, but the expedition was not allowed to count as 'war service' even though the 5th Punjab Infantry was involved in some fighting.

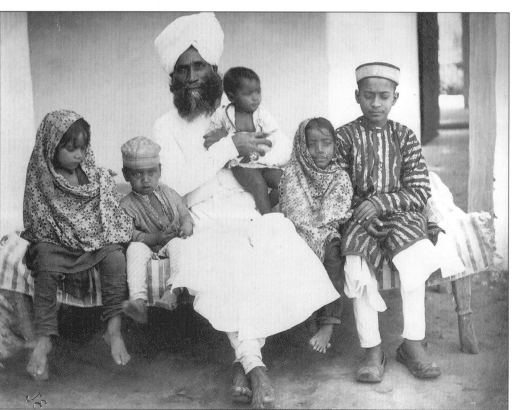

No. 3723 a

Office of the Adjutant General in India,
Head Quarters,
Simla, 27th October 1884.

From
The ADJUTANT GENERAL in INDIA,

To
Lieutenant F. B. Mein,
5th Punjab Infantry.

Sir,

I am directed by the Commander-in-Chief to forward for your information the enclosed extract from the despatches of Brigadier General T. G. Kennedy, c. b., lately commanding the expedition to the Takht-i-Suliman, and to acquaint you that His Excellency has approved of the extract being used and referred to as if the despatches had been published in the Gazette of India.

2. The expedition will not be entered in the Army List as war service.

I have the honor to be,
Sir,
Your most obedient servant,
G. R. GREAVES, *Major-General,*
Adjutant General in India.

In the Sultanpur-Kulu Valley, *c.* 1884. The family on leave or holiday in Sultanpur, or Kulu, the main village in the Kulu subdivision of Kangra distict. This remote mountain area, about halfway between Amritsar and Ludhiana was a popular walking, hunting and shooting resort.

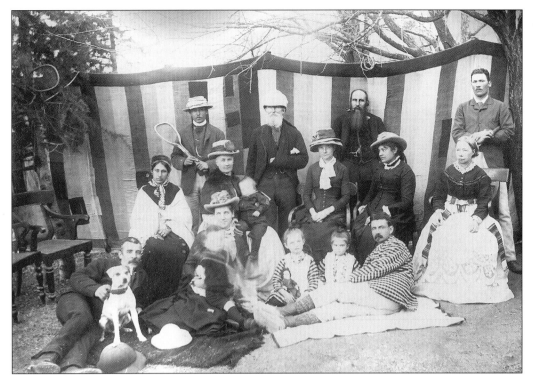

Thakurs (headmen) of Lahoul. Lahoul, in the Kulu district, lies at the foot of the Rohtang Pass.

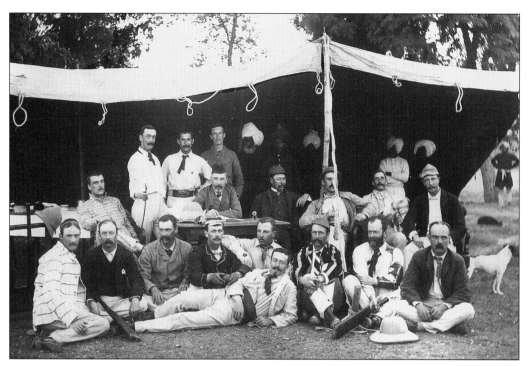

Officers at Dera Ismail Khan, 1883-84. Left to right, back row, standing: Lt Grover (5th Punjab Cavalry); Surgn. Rogers (Medical Department); Lt Johnstone (5th Pun. Inf.). Middle row, seated: Lt Cooper (5th Pun. Inf.); Lt-Col. McKinnon (5th Pun. Inf.); Maj. Hall (5th Pun. Inf.); F.B. Mein (5th Pun. Inf.); Lt Birch RA; Mr A. Bean (Postal Department). Front row, seated: Lt Batten (2nd Punjab Cav.); Capt. Stuart (2nd Pun.Cav.); Capt. Pollock (1st Sikhs); Lt Stewart (1st Sikhs); Lt Dallas (1st Sikhs); Lt Norman (2nd Pun.Cav.), reclining; Mr Meredith (Civil Service); Col. Lance (2nd Pun.Cav.); Capt. Campbell RA.

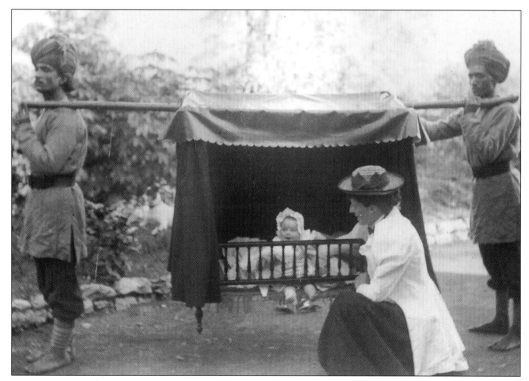

The domestic round: taking baby for some fresh air. Daphne Mein is seen with here mother and Indian bearers in a portable cot, 1891.

Subalterns' Quarters in Fort Dhulipgarh, Kohat, with the 5th Punjab Infantry in the foreground. The 5th Punjabis were here in December 1884. Kohat was one of the major frontier bases, manned by the Punjab Frontier Force.

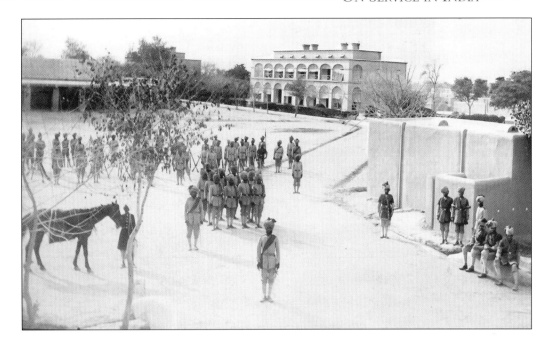

Officers and ladies at Edwardesabad, 1885. Edwardesabad was the British cantoment at Bannu – another important frontier garrison town. Left to right, back row, standing: Capt. Birch RA; Lt Stewart (1st Pun.Cav.); Lt Shaw (1st Pun. Cav.); Lt Cunliffe (6th Punjab Inf.); Col. and Mrs Stewart. Middle row, seated: Mrs Mayer; Miss Gisborne; Mrs Birch; Mrs Jameson; Mrs King. Front row: Revd Mayer; Mrs Ross; Capt. Jameson (5th Punjab Inf.); Capt. King RA; Col. Ross (5th Punjab Inf).

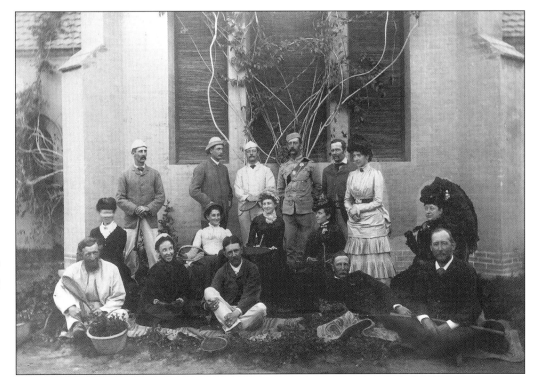

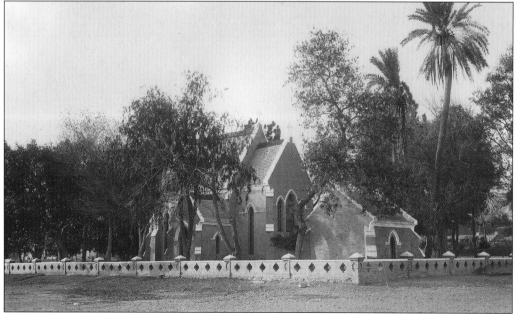

Above: A familiar photograph of the drill and sports field at Kohat. St Augustine's church and the Raquets club to the left. J.E. Mein's house was to the left of the Racquets Club (just out of this view).

Left: St Augustine's church, Kohat,0 was the scene of many Frontier marriages, baptisms and funerals and the repository of many of the colours and monuments of the Punjab Frontier Force. The church was destroyed by fire in 1938 but fortunately many of its monuments were saved. These, and others, are now in St Luke's Church, Chelsea, the present location of the Punjab Frontier Force Chapel and are destined to go into the National Army Museum.

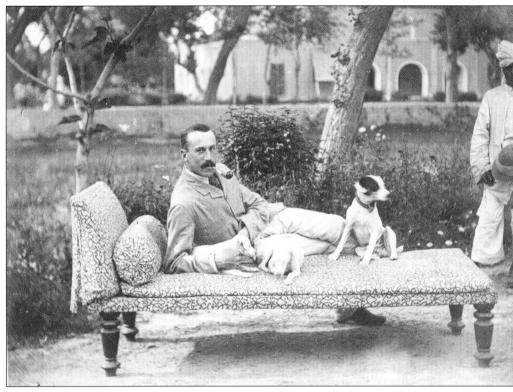

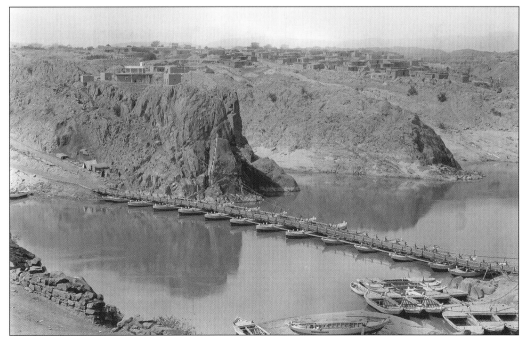

Above: Mrs Ellis and dogs.

Top right: F.B. Mein pictured with his dogs Spot, Grip and a puppy at Kohat in 1885.

Bottom right: The bridge of boats at Khushalgarh. This bridge fifteen miles east of Kohat was one of the few crossings of the Indus south of Attock, thirty miles away to the north. It was later replaced by a cantilever road and railway bridge.

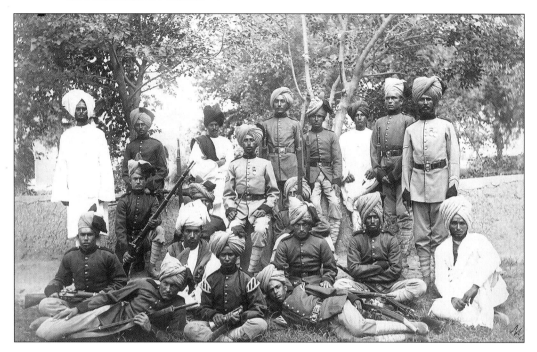

'Some of Fred's Recruits': recruits and Instructors, 5th Punjabis, c. 1884. Like many Indian regiments the 5th Punjabis was comprised of a mixture of different tribes or 'classes'. This encouraged a company loyalty and a 'family feeling'. The mixed Class Composition of the 5th Punjab Infantry in the mid-1880s is seen clearly in this and the following sequence of photographs. Many were drawn from the frontier tribes where were frequently the targets of British punitive expeditions.

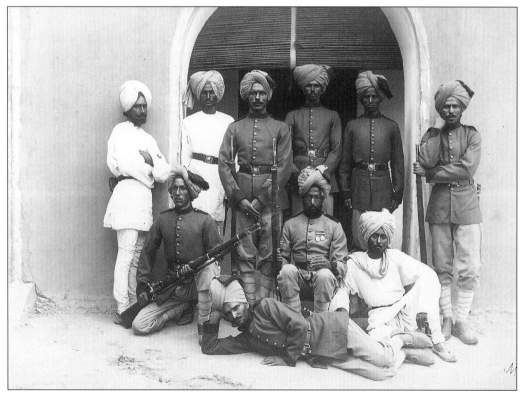

Dogras: One Company. Dogras were of Rajput stock and lived in Kashmir and Jammu, to the north of the Punjab.

Khattacks: One Company. The Khattacks were trans-Indus Pathan tribesmen recruited from the Kohat Bannu area.

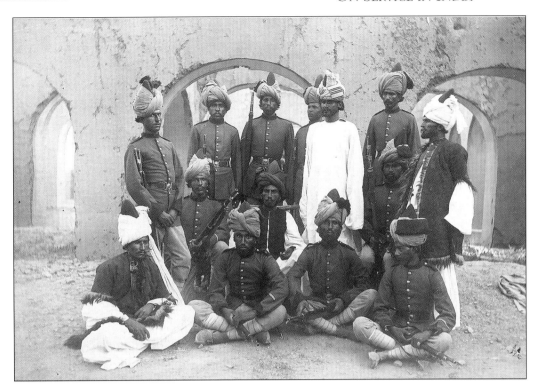

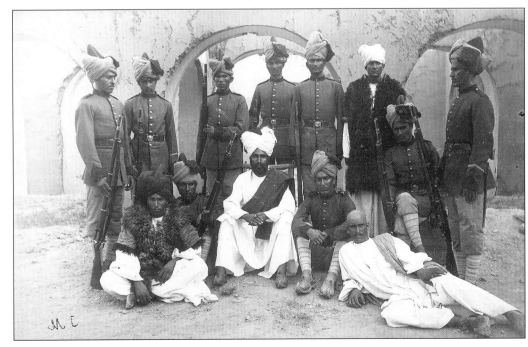

Afridis: One Company. The Afridis were recruited from the tribal areas across the Indus and especially from around the Khyber Pass and Bazar Valleys.

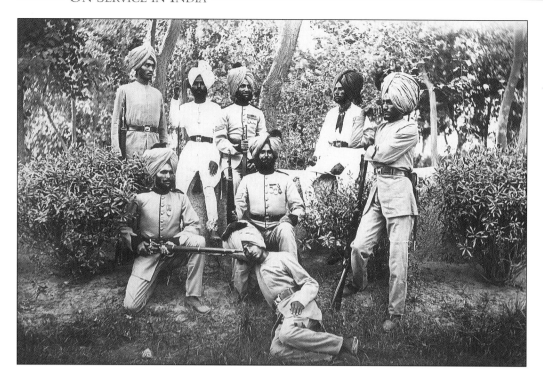

Sikhs: Three Companies. Since the conquest of the Sikh kingdom the Khalsa, in 1849, the Sikhs had served in the British and Indian Army. They were very highly regarded as a 'martial race' and as fine soldiers.

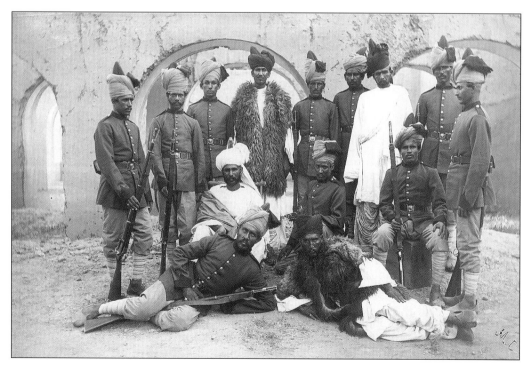

Eusofzais: One Company. Eusofzais, or Yusufzais inhabited the northern regions of the Frontier, around Dir, Swat and Buner.

Punjabi Muslims: One Company. The various Muslim groups of the Punjab, along with the Sikhs, provided the backbone of the Bengal army and were recruited in large numbers.

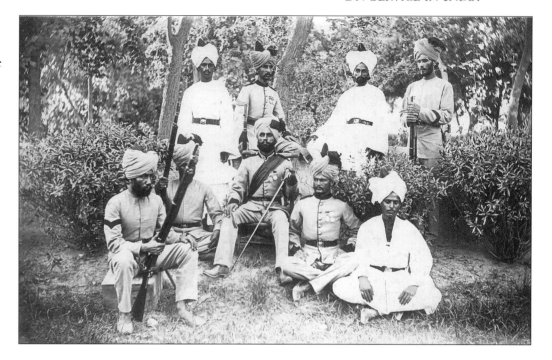

A view of Mussoorie, 1886. Mussoorie was a hill station situated near the Himalayas north of Dera Dun. Its permanent Anglo-Indian population was swollen by large numbers of European visitors – mainly officers and their families – during the hot season.

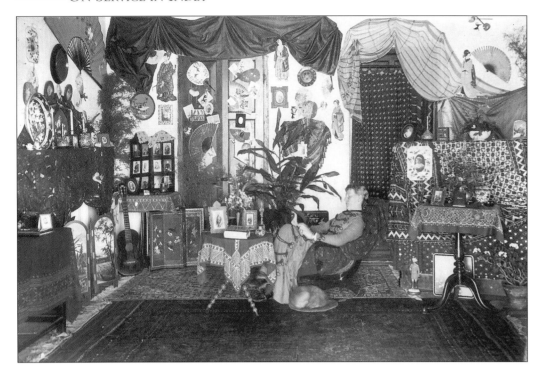

The drawing room of J.E. Mein's house at Mussoorie, 1886, with Mrs Mein relaxing. This is a room filled with family treasures and comforts which moved from station to station as duty dictated.

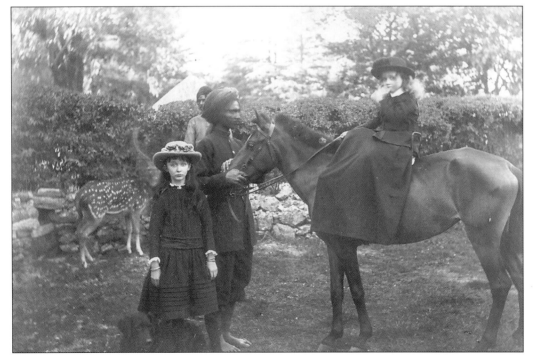

The two daughters of J.E. Mein with Indian house-servants. The deer in the background was a family pet.

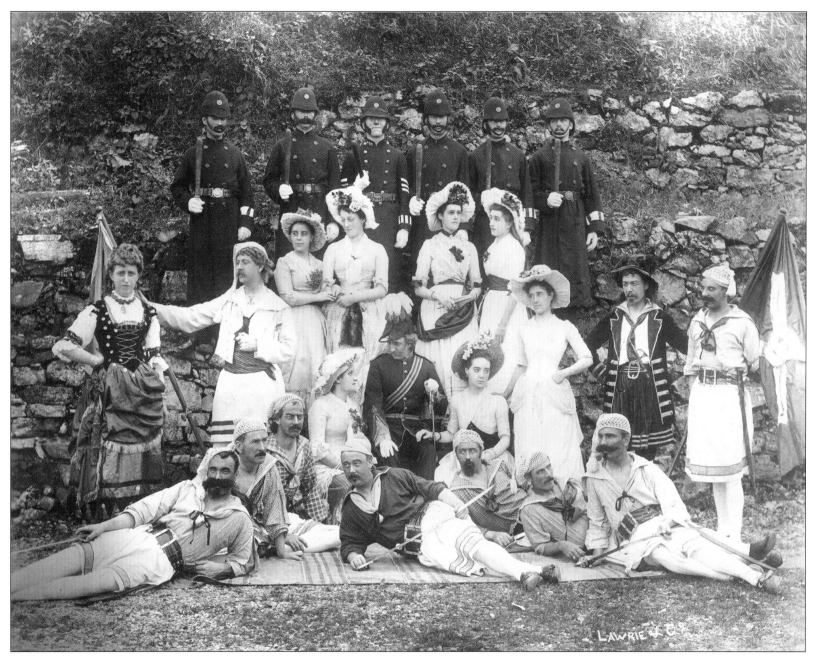

Amateur dramatics: performing *The Pirates of Penzance* at Mussoorie, 1886. Play-acting was one form of popular diversion for those enduring life on a military station in India, as elsewhere throughout the Empire.

Officer's House, Dera Dun, 1886. Dera Dun, sixty miles from Chakrata and thirty miles from Hardawar, was the headquarters of the Dera Dun district. It became a British military base after it was ceded by the Gurkhas in 1815 and the Indian Military Academy was later built there.

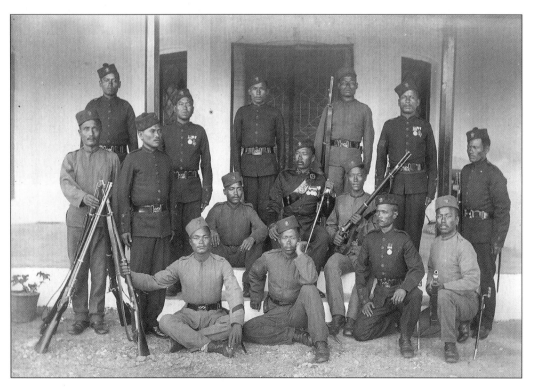

A group of 2nd Gurkhas at Dera Dun, 1886.

The Mess of the 2nd Gurkhas, Dera Dun, 1886. Dera Dun was the Depot of the 2nd Gurkhas.

Massed Bands at Meerut, January 1887, comprising bands of the 3rd Dragoon Guards, 1st King's Own Scottish Borderers, 4th Rifle Brigade and 2nd Seaforth Highlanders. Military bands often playe for public entertainment and at social functions.

J.E. Mein's house at Meerut, March 1887, with his wife in the foreground.

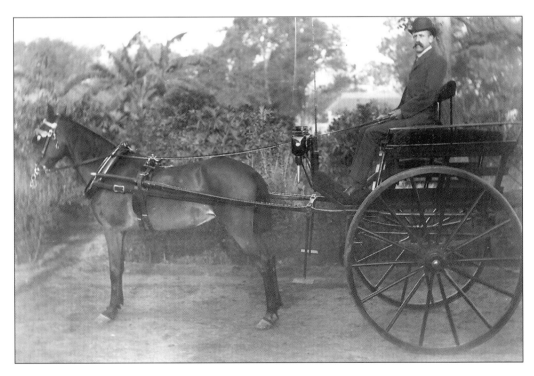

Off duty: J.E.Mein in his pony and trap at Meerut in 1887.

A view of Hardawar and its temples. Hardawar is an ancient town on the right bank of the Ganges, an important Hindu religious centre and the site of the huge *Kumbh Mela* festival every twelve years.

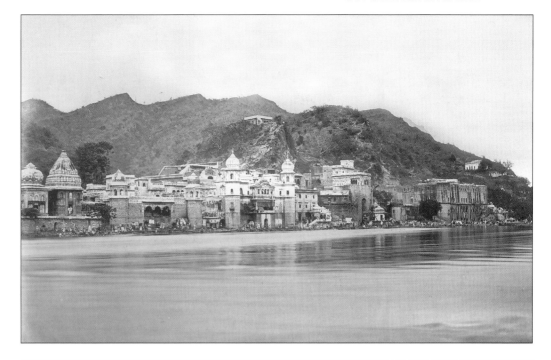

A Police group, Kohat, 1897. On the left, middle row is Maj. Henry Percy Poingdestre Leigh, formerly of the Royal Artillery, Deputy Commissioner, Kohat. He wears the ribbons of the CIE (awarded 1892) and the IGS 1854, awarded for Samana 1891. On the right is Mr.Donald, Deputy Superintendent of Police, Kohat.

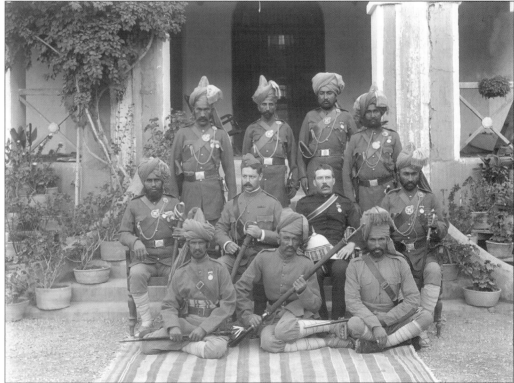

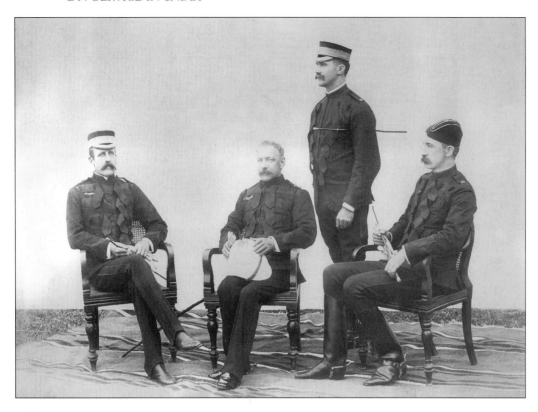

Staff Officers at Meerut, 1887. Left to right: Capt. J.E. Mein (Deputy Assistant, Adjutant General for Musketry); Col. Hanna (Deputy Judge, Advocate General); Maj. Burton (Brigade Major); Maj. Gordon (Deputy Assistant, Quarter Master General). Col. Henry Bathurst Hanna was the author of a three-volume history of the Afghan War.

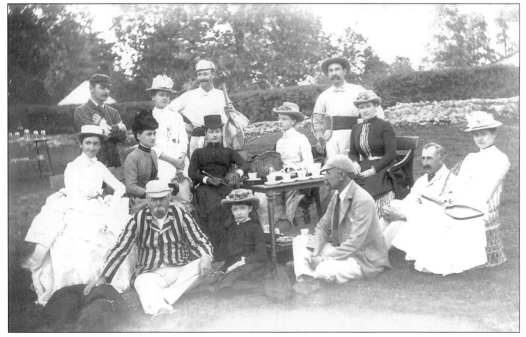

A tennis party at Mussoorie, another part of the social round of the hill-stations of British India, June 1887. The ladies wear the very full skirts which fashion and etiquette demanded, even in sport.

J.E. Mein's house, 'Hermitage Cottage', Mussoorie, 1888. Mrs Mein stands near the doorway with a uniformed servant nearby.

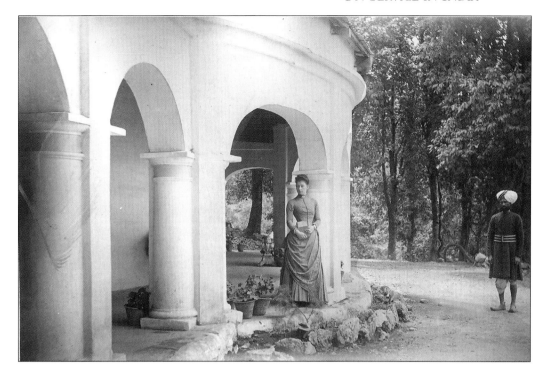

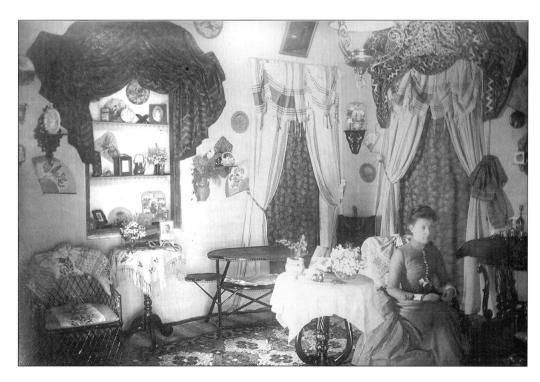

Mrs Mein at home: a typically Victorian cluttered but comfortable-looking room in Hermitage Cottage, 1888.

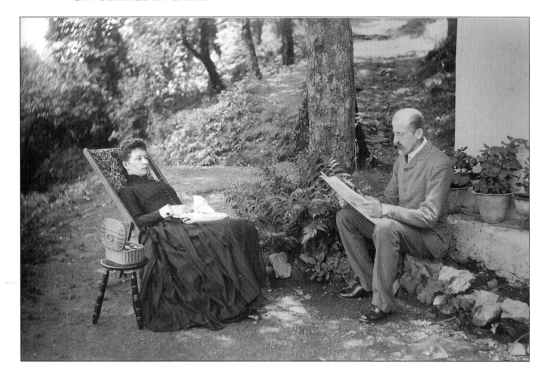

J.E. Mein and his wife, Ethel Maude Mary (née Hadow) relazing at Mussoorie, 1888. They were married in Meerut on 26 March 1888.

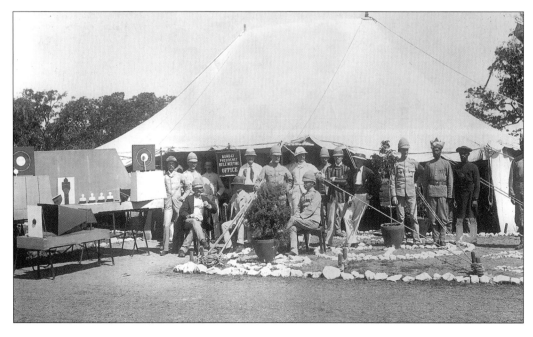

A meeting of the Bombay Presidency Rifle Association in 1888. Shooting clubs were very popular in India and their members often formed the nucleus of Indian Volunteer forces, made up of British ex-patriots.

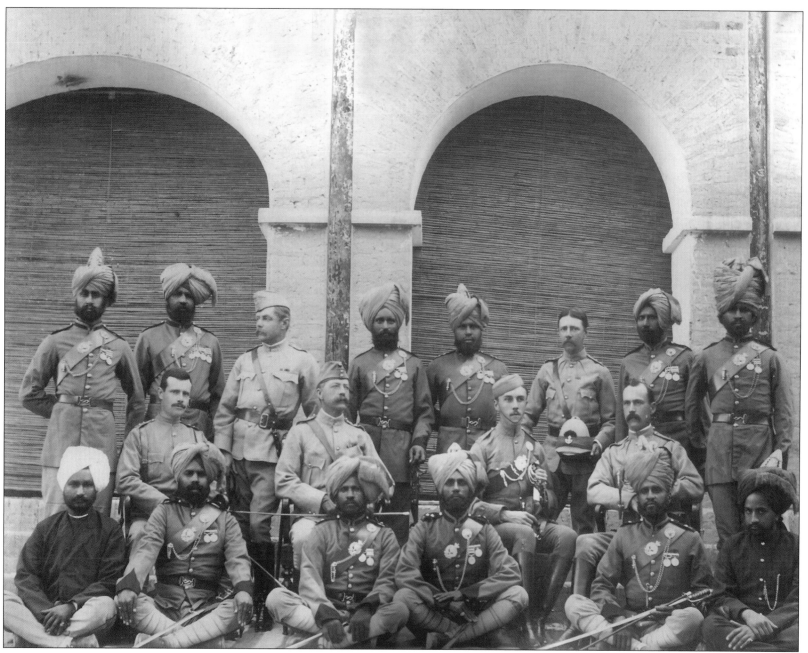

A group of 5th Punjab Infantry, *c.* 1889. The British officers, middle row, left to right are: Surgn. Leslie; Col. Strettell; Col. Vallings; Lt Creagh; Capt. Jameson; Lt F.B. Mein. The soldiers wear the India General Service Medal, 1854–95, and the medal for the Afghan War, 1878–80. The Indian officer, second from the left, back row, is Subadar Budh Singh. He wears the Indian Order of Merit, the Indian Mutiny Medal, the India General Service Medal, 1854, probably with clasps 'Northwest Frontier' and 'Jowaki 1877-8' and the Afghan War Medal with clasps 'Peiwar Kotal', 'Charasia' and 'Kabul' earned with the 5th Punjab Infantry.

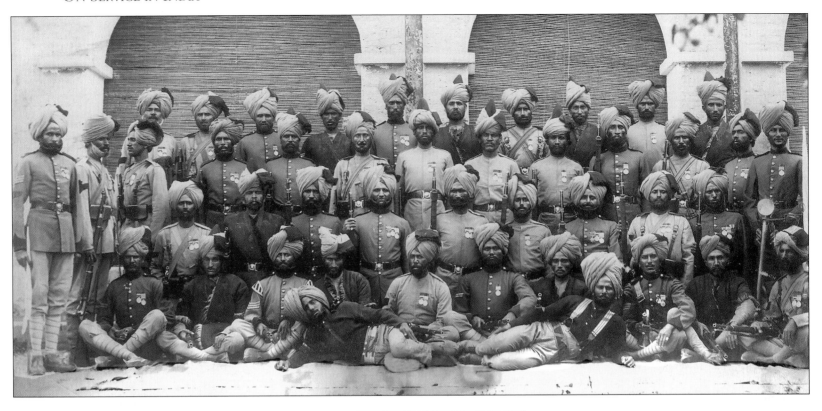

Above: Indian soldiers of the 5th Punjab Infantry, *c.* 1889. Two winners of the Indian Order of Merit are identifiable, in the second row from the front, wearing their IOM medals. The one to the left is Sarwan Singh and to the right is Man Singh. The men wear the India General Service Medal, 1854, most of them probably bearing the clasp 'Jowaki 1877-8' and the Afghan War Medal with various clasps.

Left: J.E. Mein's house, 'No.244, Circular Road', in Meerut, 1889. He is seen with his horse and trap outside the house (also see p. 72).

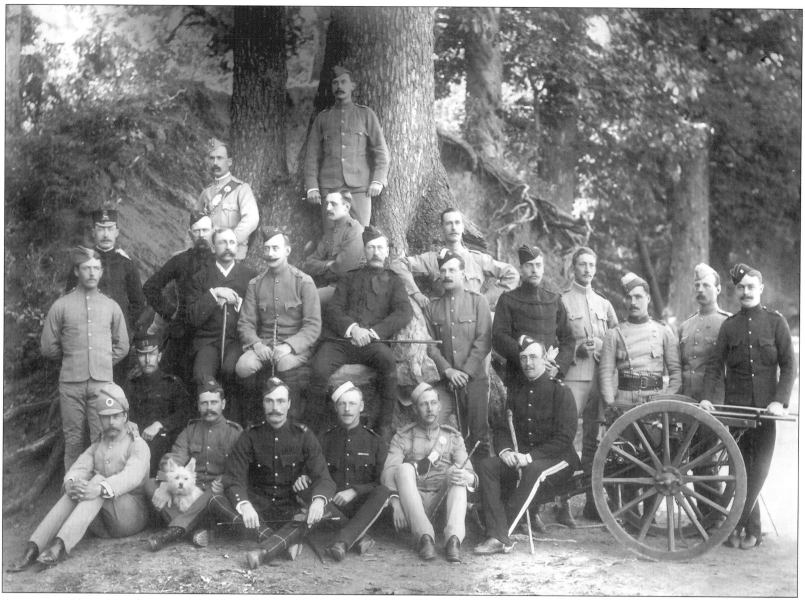

A group at Changla Gali, 2nd Musketry Course, 19 August 1889 to 29 October 1889. Changla Gali, near the popular hill station of Murree, became a British military base in 1853 and later the site of the Indian Army School of Musketry. Left to right, at the back, against the tree: Lt Towsey (West Yorks). Back row: F.B. Mein (5th Punjabis); Lt Badcock (4th Gurkhas), with arms folded. Middle row: Lt Herbert (25th Punjabis), in the light uniform; Lt Barrington (W.Yorks); Capt. Faithfull (DAAG); Surgn. Cree (Medical Dept.), leaning on cane; Lt Edwards (5th Punjab Cav.); Maj. Barlow (DAAG); Lt Vyvyan (Devon Regiment), leaning against tree; Lt Campbell (25th Punjabis), with side cap; Lt Housden (18th Bengal Cav.); Lt Cooper (1st Sikhs); Lt Prendergast (4th Punjabis); Lt. Fryer; Lt Gough (12th Begal Cav.). Front row, seated: Lt Ross (15th Sikhs); Lt Woodward (37th Dogras); Lt Hobbs (15th Bengal Lancers); Lt Sandes Lumsdaine (Highland Light Inf.); Lt Whiffen (13th Ben. Lcrs); Lt Dunsterville (29th Punjabis); Lt Lewis (4th Bombay Cav.).

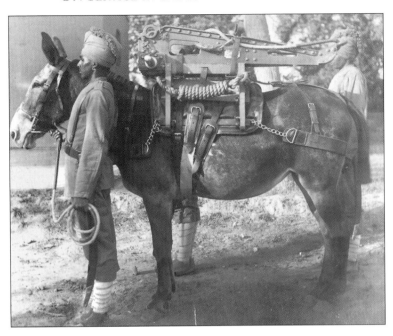

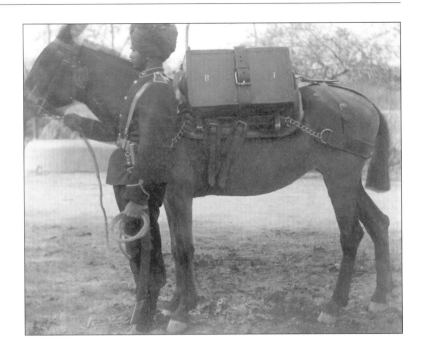

This sequence of photographs show a mountain gun of No. 4 (Hazara) Mountain Battery broken down and carried on mules, ready to move. This is an example of Kipling's famous 'screw guns' – so named because they screwed apart and together for ease of transport and famous because Rudyard Kipling wrote a poem about them. These guns were much favoured in frontier warfare and were capable of crossing difficult terrain and being brought quickly into action in the heart of the enemy territory.

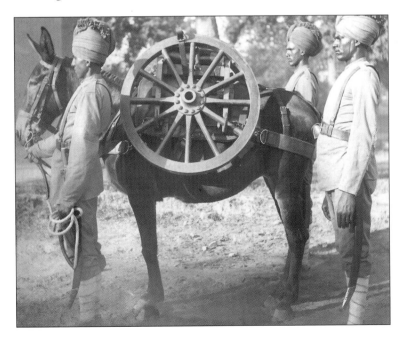

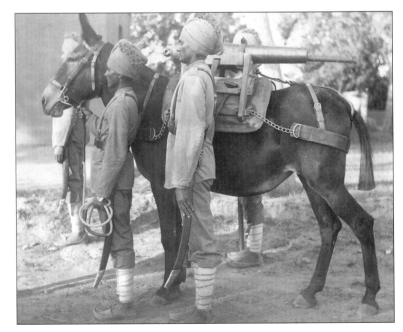

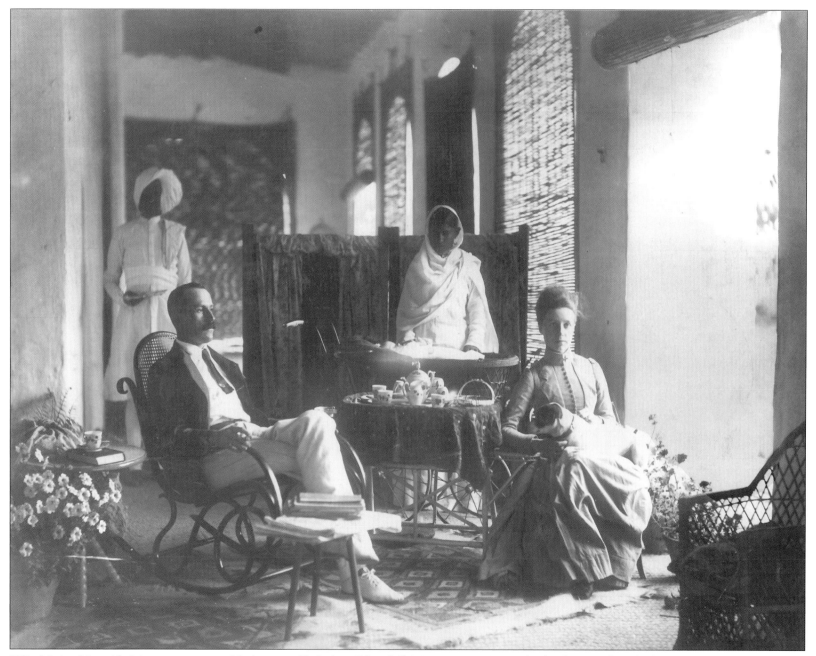

F.B. Mein, his wife Mary, servant and baby son, Debrisay Blundell Mein (see p. 9) in the background with their dog 'Major', on 'Our Verandah', Kohat 1890.

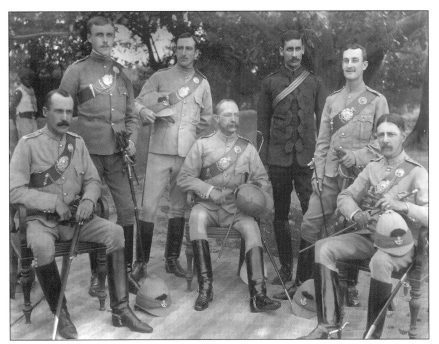

Right: Officers of the 5th Punjab Infantry, Kohat 1890 in Dress uniform. The original caption reads: 'Annual Boot and Helmet Show – This Style the Best – 10% Discount for cash – Order early.' The officers are, left to right: F.B. Mein; Lt Creagh; Lt Johnstone; Col. Vallings; Surgn. Sunder; Lt Allen; Capt. Jameson.

Below: British and Indian Officers of the 2nd Punjab Infantry, *c.* 1890. It is possible to identify tentatively some of the officers. Fifth from left, back row, is probably Lt A. Nicholls, wearing the Egypt medals awarded for service in 1882 with the 1st Berkshire Regiment. Seated far left, middle row, may be Surgeon Capt. A.H. Nott. Next to him, seated, may be G.W.B. Swiney, wearing the Afghan medal with two clasps earned with the 72nd Highlanders. In the centre, seated, may be Maj. R.R.N. Sturt with the Afghan Medal and 'Peiwar Kotal' clasp.

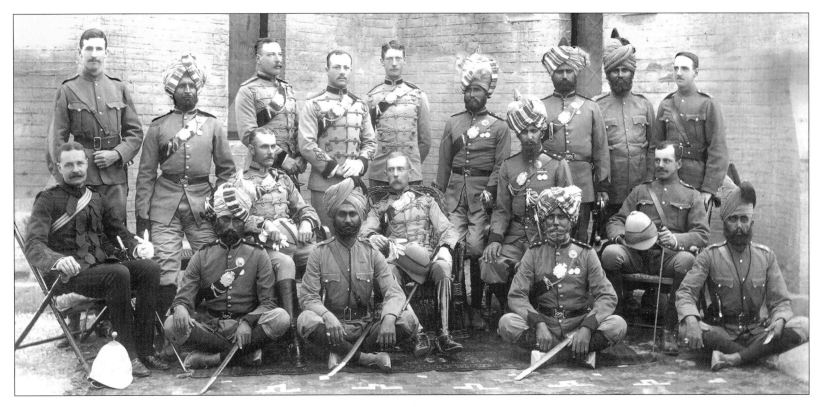

F.B. Mein's sketch of Gwadar, 1891. First Miranzai expedition, Samana Ridge. Like most army officer, F.B. Mein was a competent artist – as was his brother, J.E. Mein, many of whose letters are beautifully illustrated.

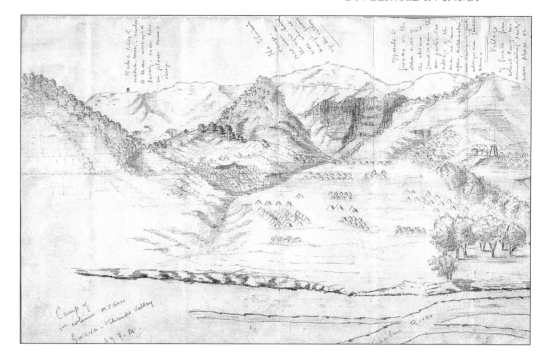

Taking afternoon tea: A relaxed shot of John Mein with his wife and daughter Daphne, *c.* 1894.

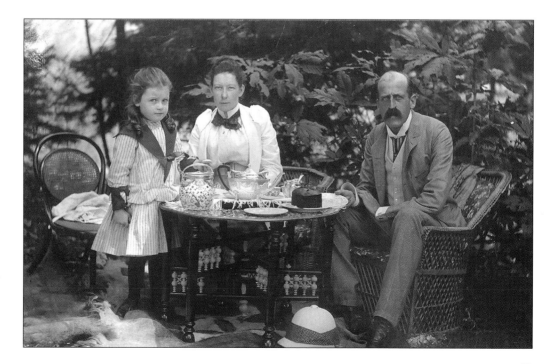

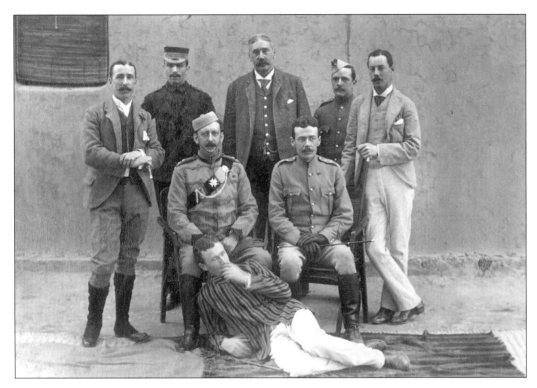

Officers of the 6th Punjab Infantry, Bannu, January 1892. E.W.Cunliffe, who succeeded J.E. Mein in command of the 6th, is seated middle row, left. He served in Afghanistan, Samana Ridge 1891, in Waziristan 1894-95 and on the North West Frontier in 1908, commanding the 6th Punjab Infantry in the Zakkha Khel campaign. He died suddenly in Southsea in 1912.

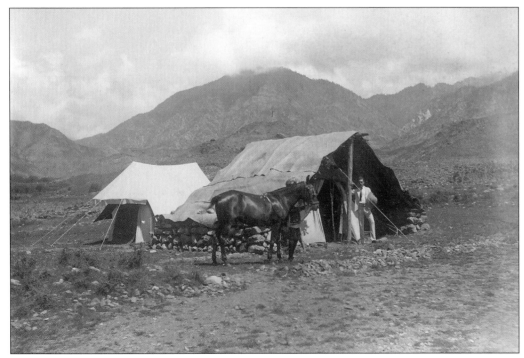

Lt W. Seton-Browne's tents, Maluna, Kurram Valley, 1893. Seton-Browne was Adjutant of the 6th Punjab infantry at the time of their service in the Kurram. He died of enteric fever in this camp on 20 July.

The Rifle Range of the 6th Punjabis, Kurram Valley, 1893. It was built by the regiment for its own use whilst stationed in the Kurram Valley – a remote area linking the Frontier with Afghanistan and a frequent site for military manoeuvres and exercises.

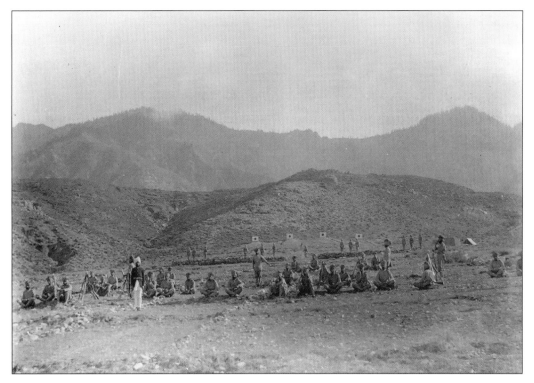

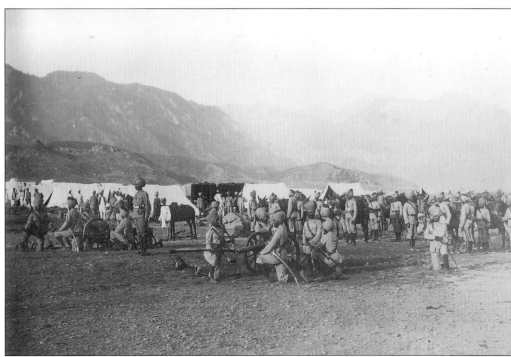

No. 3 Mountain Battery, Maluna, Kurram, 1893. Mountain Batteries (also see p. 80) were much favoured as artillery in harsh terrain such as this.

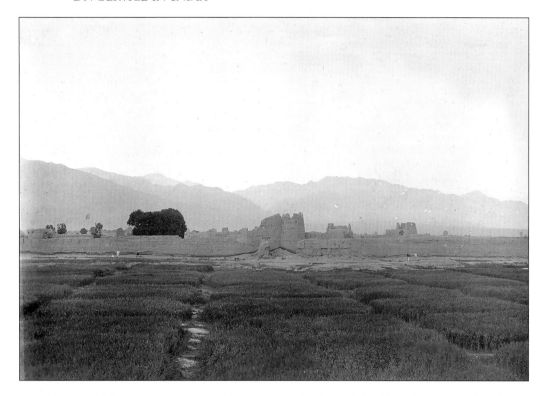

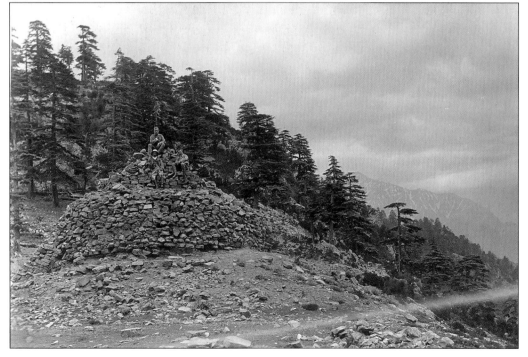

Above: Looking up the Maluna nullah (river bed) in the Kurram valley, 1893.

Top left: Old Kurram Fort, five miles south-east of Parachinar, Kurram, 1893. Parachinar had been a British base during the Afghan War, as British troops passed through Kurram into Afghanistan.

Bottom left: On the summit of the Peiwar Kotal, 1893. The Peiwar Kotal (Pass) links the Kurram valley with Afghanistan and was the scene of fighting in December 1878, when it was stormed by forces (including the 5th Punjab Infantry) under Sir Fred Roberts.

Right: Indian officers of the 6th Punjab Infantry in the Kurram Valley, 1893.

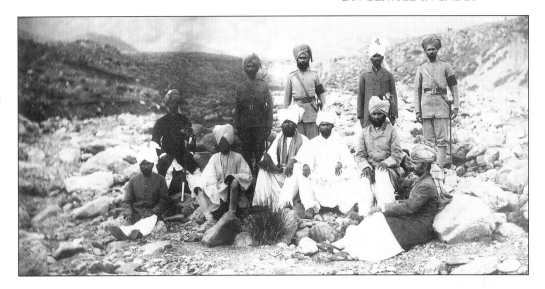

Below: A group of Piffer officers with their wives an children at Kohat, 1893. J.E. Mein is seated front row, right, with arms folded. Third from left, back row, is Capt. Jameson, 5th Punjab Infantry. A fine array of fashionable clothing is on display.

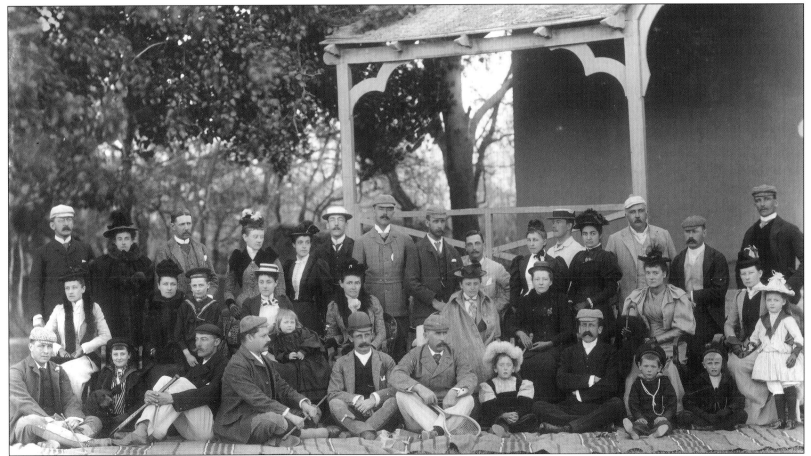

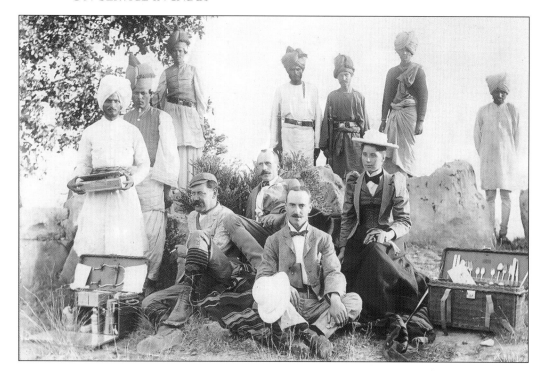

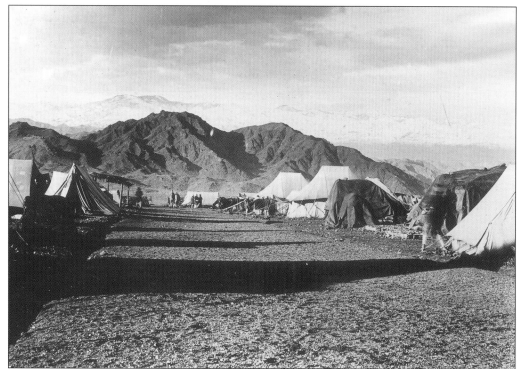

Above: A watercolour by Mrs F.B. Mein depicting Sangar Post, Dhar Fort. This was one of the chain of forts built by the British along the Samana Ridge after the campaigns of 1891.

Top left: A picnic party on the Samana Ridge, 1895. After the British campaigns on the ridge in 1891, permanent garrisons and posts were maintained there. Left to right: Maj. Fred White; F.B. Mein; Surgeon T. Grainger. Mrs Mein is to the right.

Bottom left: 'Main Street, Camp of the 6th Punjab N.I. at Datta Khel, 1896' The 6th Punjab Infantry served with a column in the Tochi Valley from February 1895 to January 1897. It was first based at Dehgan, with outposts at Miran Shah, Idak and Saidgi. It moved to Datta Khel on 30 August 1896 and remained there until 15 January 1897, when it returned to Bannu.

'6th N.I. Camp, Datta Khel.' The 6th Punjab Infantry in the Tochi Valley, 1896.

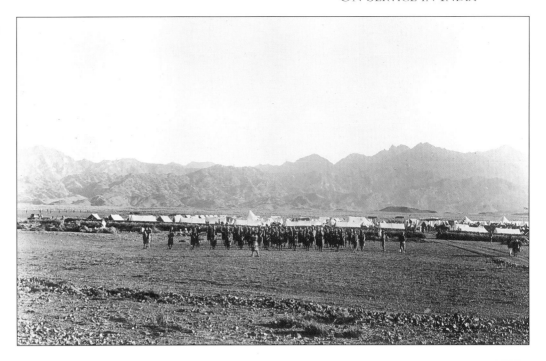

Some officers of the 1st Punjab Infantry, *c*. 1897. Only a few are named. Left to right, back row: -?-; A.M. Houston; -?-; -?-. Middle row: W. Kirkpatrick; -?-; Col. W. du Garde Grey; -?-. Front row: Dr F.R. Ozzard; -?-. F.B. Mein joined the 1st Punjab Infantry in June 1897. Note: although the Surgeon is identified as 'Dr Ozzard', he looks rather like Surgeon C.C.Cassidy who was mortally wounded at Maizar (see next page).

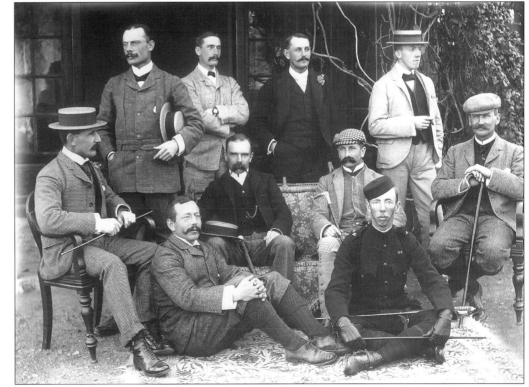

The Maizar Incident

On 10 June 1897, a column of troops accompanied Mr Gee, the Political Officer for the Tochi Valley, from Datta Khel to Maizar to levy fines upon the Madda Khel clan for the murder of a Hindu Writer at Sheranni. The force consisted of 12 men of the 1st Punjab Cavalry, 200 men of the 1st Sikhs, 100 men of the 1st Punjabis and two guns of the 6th (Bombay) Mountain Battery, all under the command of Lt-Col. Bunny, 1st Sikhs. At first, all went well. The column camped near a Drepilari village and was provided with food and a chance to rest and talk with the local leaders. The pipers of the 1st Sikhs began to play for the entertainment of the locals. However, around 1p.m., the column was suddenly fired on from the nearby village and from three or four others surrounding the campsite. Col. Bunny was wounded very early on, as were the artillery officers Browne and Cruickshank as they brought their two guns into action. As ammunition was short, Bunny gave the order to retire to a nearby ridge, at which point, enemy tribesmen began to attack from all sides. Surgeon Cassidy and Lt Higginson were wounded – so that all the British officers had by now been hit. To give their colleagues a chance to retire, a mixed group of 1st Sikhs and 1st Punjabis under Subadars Narain Singh and Sundar Singh made a stand by a walled garden so that the wounded could be carried away and the column withdrawn. They were subjected to a tremendous fire and many were killed, including Subadar Sundar Singh. A fresh stand was made by the retiring column, which was reduced to firing blanks from the mountain guns and by now, Lt. Cruickshank and Captain Browne were dead. The retreat continued from ridge to ridge until the Sheranni plain was reached, by which time the enemy was outflanking the dwindling column. Eventually, after over four and a half hours of fighting, the survivors were met by reinforcements summoned from Datta Khel and the enemy beaten off.

In addition to the officers killed, the incident cost the lives of twenty-one men of the escort, with a further twenty-eight wounded. The conspicuous bravery of many of the escort during the fighting retreat was recognized by a large-scale award of the Indian Order of Merit. This 'Maizar Incident' caused the formation of the Tochi Field Force to exact retribution from the Madda Khel of the Maizar area and led ultimately to the burning of the Drepilari villages and of Sheranni and the imposition of a large fine on the Madda Khel.

A view of Maizar, 1897, showing the trees near which the officers were sitting when the attack began. Note the dead mules in foreground – perhaps mules of No. 6 Mountain Battery. The lane (left) was where Subadar Sundar Singh was killed. He, with a number of others, 'behaved with the greatest gallantry' and 'made a most determined stand' near this garden wall. The heaviest casualties occurred here.

A group of soldiers of the 1st Sikhs and 1st Punjabis, noted as winners of the Indian Order of Merit, 1897. Most of these men are presumably IOM winners from the Maizar incident, 10 June 1897. There are no names given, but it is possible to identify Bugler Bela Singh, 1st Punjabis (front row, far left), who received the IOM for 'fighting bravely and effectively with a rifle he saved from one of the killed' and for gallantry in carrying away and distributing ammunition. If these are indeed IOM winners, the photograph may well have been taken on the occasion of the presentation of the awards, since none of the men is wearing the IOM ribbon or the IGS 1895 ribbon.

The 1st Punjab Infantry on a march in the Tochi Valley, 1897. The Tochi Field Force (which included the 1st Punjab Infantry) was sent into action to deal with the Madda Khel after the Maizar attack.

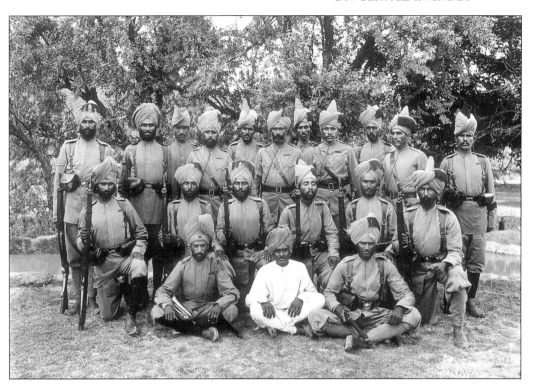

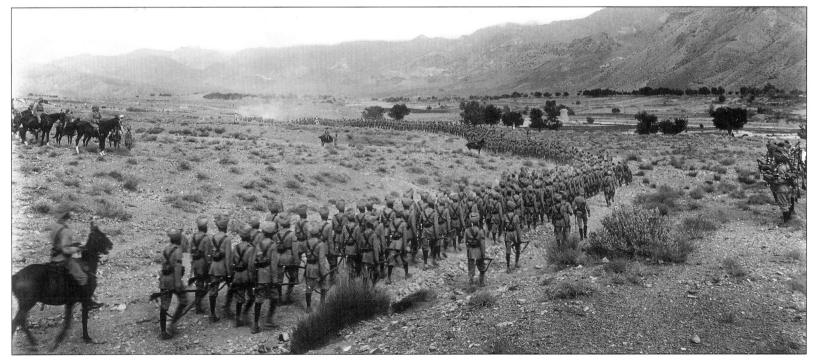

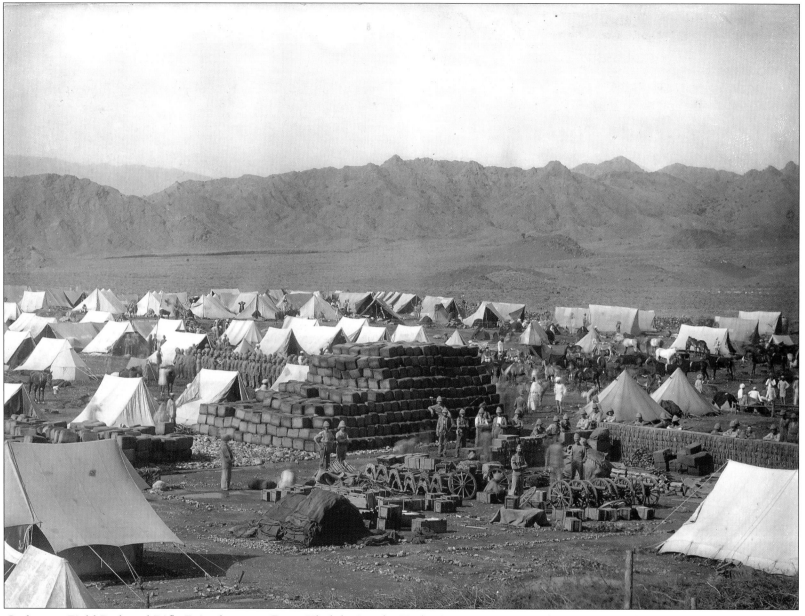

Ordnance Field Park and Rifle Brigade camp, Datta Khel during the Tochi Campaign, 1897. This gives a good idea of the supply problem faced by a mobile column in enemy territory; the boxes presumably contain ammunition.

Retribution: the destruction of the towers of a Drepilari village at Maizar, 1897. The British column under Mr Gee and Lt-Col. Bunny camped near this village in Maizar and it was from here that the attack upon them began.

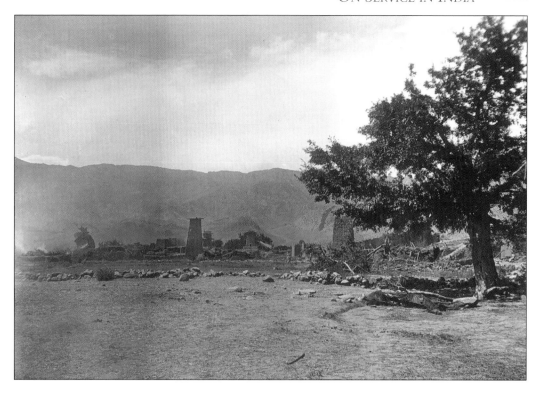

Retribution: the burning of Sheranni village, July 1897. The inhabitants of Sheranni played a major role in the attack on the Maizar column as it fought its way back. The burning of 'hostile' villages and/or the destruction of their defensive towers was a routine practice in the fighting on the North West Frontier.

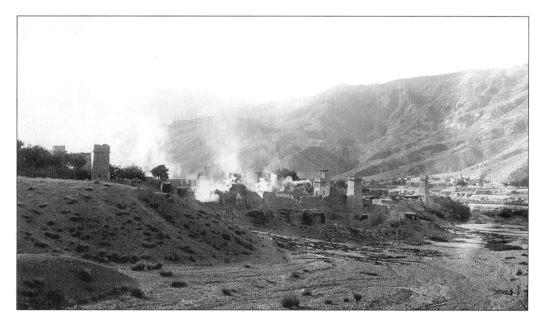

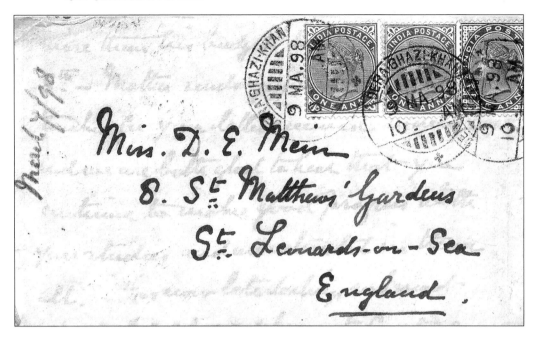

A letter from J.E. Mein to his daughter in England. The Meins seem to have been considerable letter-writers and many examples still survive. This one dates from 1898 and was sent from the frontier garrison town of Dera Ghazi Khan.

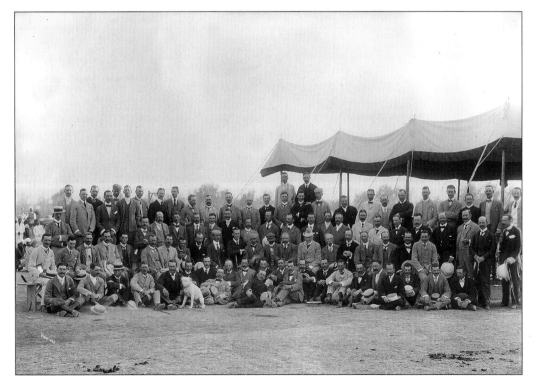

Officers of the Punjab Frontier Force, Kohat, 1900. This and the next photograph were taken at Kohat during the gathering to celebrate the 50th Anniversary of the formation of the Punjab Frontier Force (PFF) – the specialist force trained for tribal operations on the North West Frontier.

Officers (and ladies) of the 6th Punjab Infantry at Kohat in 1901. Only some of the people can be named: They are, left to right, back row: Lt H. de C .O'Grady; Lt F.D. Browne. Middle row: -?-; Col. J.E. Mein; Maj. E.W. Cunliffe. Front row: Lt T.Mc.C. Nicholson; Capt. C.C. Fenner. The black armbands are mourning wear following the death of Queen Victoria. C.C. Fenner took the 59th Rifles – as the 6th Punjab Infantry became in 1903 – to France in 1914 and was killed near the Rue de Bois on 23 November 1914. Henry de Courcy O'Grady became the first Commandant of the Chitral Scouts and a Brigade Commander in East Africa, 1914-17 and in the 3rd Afghan War, 1919 (CIE). He died in 1949.

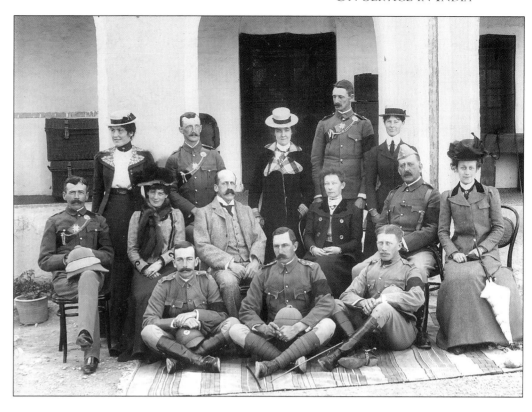

British and Indian officers, 6th Punjab Infantry, Kohat, February 1901. Only some of the officers are named. Left to right, back row: Hans Raj; Subadar Kalia; Sub. Wali Khan; Lt O'Grady; Jemadar Jaimal Singh; Lt F.D. Browne; Sub. Ditt Singh; Jem. Ghulam Raza; Lt T.Mc.C.Nicholson; Jem. Baghel Singh. Middle row: -?-; -?-; Maj. E.W. Cunliffe; Col. J.E. Mein; -?-; Capt. C.C. Fenner; -?-; -?-. Front row: all unnamed. Subadar (later Subadar Major) Ditt Singh was awarded the Order of British India, 2nd Class, for gallantry at Matta in the Mohmand campaign in 1908; he was described as 'a fine straightforward Indian officer ... a fighting man of rare courage and capacity'. He died suddenly at his home in October 1908, his death 'a grievous loss' to the Regiment.

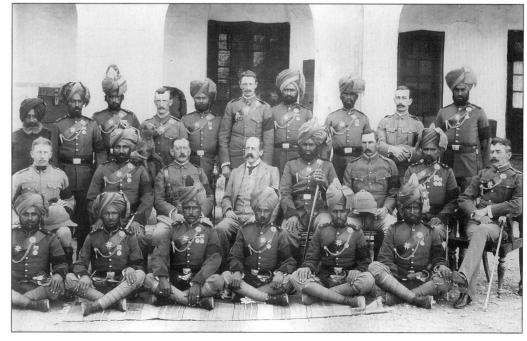

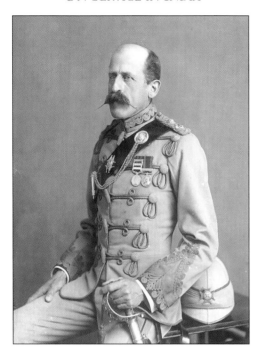

Far left: Col. J.E. Mein, Commandant, 6th Punjab Infantry. This is a fine portrait of J.E. Mein towards the end of his active career in the Punjab Frontier Force. The officers' Dress uniform of the 6th Punjab Infantry is shown very clearly.

Left: A certificate registering J.E. Mein for service during the First World War. He was sixty-three when the war began.

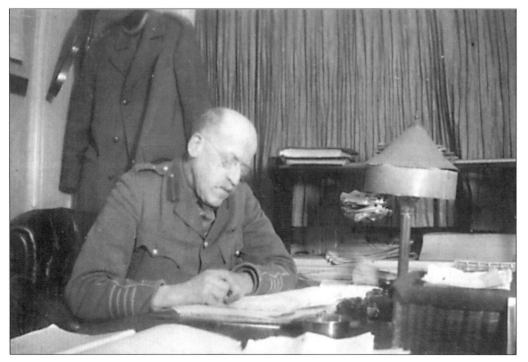

Col. J.E. Mein as Army Censor, London, during the First World War. According to his own Record of Service: 'When the Great War broke out on August 4th, 1914, I volunteered for service in the Field and was pronounced medically fit for the same, but was rejected under the age clause. Towards the end of October 1914, I was offered employment as Military Censor which I accepted and was posted for duty at the Commercial Cable Company, 63-64, Gracechurch St., E.C., where I joined on the 31st October, 1914 and remained till 28th July 1919 on which date I was demobilised, thus completing a further period of nearly five years of strenuous office work which, thank God, I weathered well'.